gone

Photographs of Abandonment on the High Plains

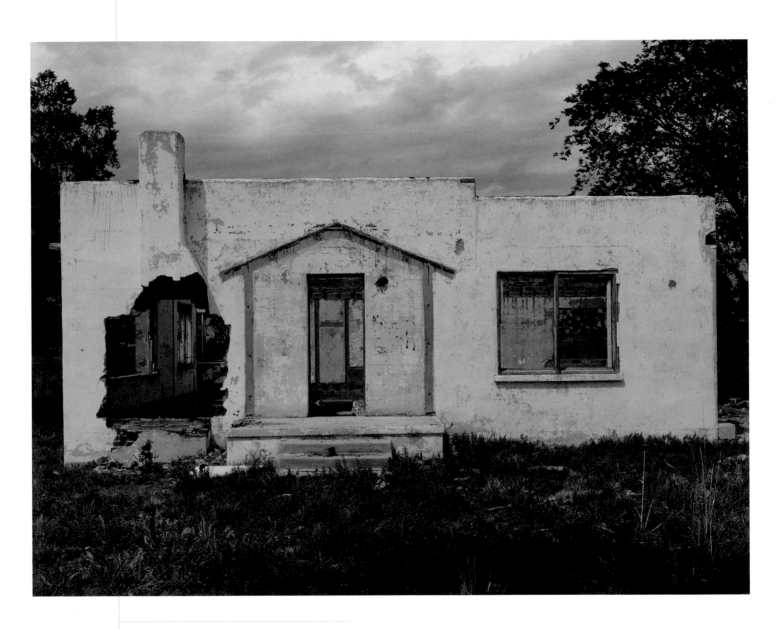

*1. Exterior view of a house near Las Vegas,
eastern New Mexico, July 21, 1990.*

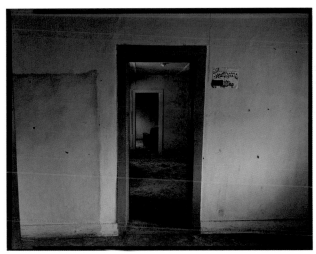

gone

Photographs of Abandonment on the High Plains

Steve Fitch

University of New Mexico Press

Albuquerque

Library of Congress Cataloging-in-Publication Data

Fitch, Steve, 1949–

 Gone : photographs of abandonment on the High

Plains / Steve Fitch.—1st ed.

 p. cm.

 ISBN 0-8263-2960-8 (cloth : alk. paper) —

ISBN 0-8263-2961-6 (pbk. : alk. paper)

 1. Photography of interiors—High Plains (U.S.)

2. Abandoned houses—High Plains (U.S.)—Pictorial

works. 3. Abandoned houses in art. 4. High Plains

(U.S.)—Pictorial works. 5. Fitch, Steve, 1949– I. Title.

 TR620 .F57 2003

 779´.3678—dc21

 2002012389

Contents

Foreword

Merrill Gilfillan

RUINS ARE AN ESSENTIAL ENZYME IN ANY LANDSCAPE. They leaven the daily taken-for-granted and substantiate that most ponderous of abstractions, Time. On the Great Plains of North America, abandoned dwellings, like most anything larger than a watermelon, stand out in high, nearly defiant relief, they draw the eye. To confront them, to ponder their teasing implications, to *people* them, is instinctive and long traditional. There are wonderful stories from native plains tribes about Coyote, or someone like him, passing an old elk skull (a skull being one of the ultimate ruins) and detecting a diminutive music within it, an unexpected inner life—the mice are holding a sun dance!

During the late nineteenth and early twentieth century, the Great Plains tolerated many settlers from the eastern half of the continent, but they heartlessly expelled a similar number, and the ruins bear solid and long-lasting witness. The very climate that drove families away—the unnervingly steady dryness—now preserves, almost fastidiously, their leavings.

The word "weather" has always held a sharp edge on the plains. Early Euroamerican visitors were often shocked by it. The High Plains—the formidable, high and lonesome area between the hundredth meridian and the foothills of the Rockies—receives just fifteen to twenty inches of rain most years, a figure usually rendered laughable by the deadly high evaporation rate—in a generous year, half the water "back home" in Indiana or Missouri. Someone commented long ago that the three critical legs of colonial civilization on North America had been land, water, and trees. Homesteading on the plains you suddenly found yourself without the latter two.

And then there is the wind. More wind than anywhere in the country save, ironically, for seashores; the Texas panhandle and Cape Hatteras share about a fifteen- mile per hour average. The harmless daily winds—daily as in day after day after day—can drive one to strong drink. And then late summer brings the hot winds, from the south or southwest, that can scorch an entire cornfield in a couple of days. Abusive hail is also a Great Plains specialty and winter brings blizzards or the Norther. It is fierce, legendary weather a good bit of the time, and it can send you packing.

There are many eloquent remnants from the Dust Bowl between west Texas and Montana, old hulks eroded down to the lathings and beyond, with long dead windmills, storm cellar doors, and perhaps a single Chinese elm in the yard. These 1930s specimens are the classics of Plains relics, standing, as they do, as evidence of an historical moment, somewhat like the Irish famine of the 1840s, when economic, political, and climatological forces merged into a devastating combination. Many of these wind-hammered sites—so exposed and vulnerable—must have had a sepia-toned poignancy even at full occupancy. How could anyone even *dream* of putting down roots *here*?

But the process was ongoing through the twentieth century, Depression or none, and continues to this day. Much of the rural High Plains is still losing population, families giving up after a hundred years of trying. The funerals outnumber the baptisms, reporters like to tell us. If the weather doesn't get you, the demographic tides and generational malaise just might. There are ruins, datable by the strata of their artifacts, from any presidential

gone

administration you might name. (And how quickly, how mercilessly the wild plums and chokecherries—the kindly fruitbearers—reclaim the dooryards.) Here and there on the outer grasslands you will find a hamlet with a majority of its houses surrendered and half-heartedly boarded up. And there are plenty of those enticing habitations on the verge—old homesteads showing all the signs of vacancy: porch propped up, sheds collapsing, corral full of sunflowers—but with a late vintage pick-up truck parked outside.

They all hold a similar aura: the stark, alkaline piquancy of a squelched microcosm within a vast and unrelenting macro. It is a complex aura, at once plaintive and disturbing, wistfully proletarian and geographically ordained. Even the dustbowl classics are of too recent a vintage to fit into any sort of manageable, impersonal myth zone of "deep time"; their hollow profiles are close enough to us to be vaguely threatening. In the end their message is unmistakable: "Hearth rejected."

But now, with Steve Fitch's photographs in hand, we are given the sudden extra dimension of the interiors of such places. What from a distance appeared *vacant* now appears, to use Fitch's photographer's term, *abandoned*. A mystery of silhouette becomes a mystery of fine-grained detail.

There is a sense of hurry in the odd, seemingly random array of items left behind in most of these houses, and even in the public buildings. But it is a numb, perhaps stoic hurry that heightens the biting blend of pathos and unease, of heroics and the cut-and-run, despair and liberation. Once intimate things sit, endure, in a debris of prairie dust, rodent droppings,

festoons of shrill coral-reef-colored wallpaper. Why this? And why that? A coffee cup, a child's drawing, *two* televisions. And, like an anonymous note in a cracked bottle, the ultimate emblem of ruination, old fly-specked calendars with their Pompeiian irony bordering on sarcasm.

And after a few moments of reflection, we all drive on. We could see the ruins a long way approaching, and we will see them a good while in the rearview mirror. They stand as both fossil and echo. We leave them to their watersheds and the oceanic weather and the hawks overhead. They will be there a long, dry time. Even the coyotes hardly bother to sniff them anymore.

Merrill Gilfillan is the award-winning author of *Magpie Rising: Sketches from the Great Plains* (Pruett Publishing Co., 1988), *Chokecherry Place: Essays from the High Plains* (Johnson Books, 1998), *Sworn Before Cranes: Stories* (Orion Books, 1994), and several books of poetry. He resides in Boulder, Colorado.

gone

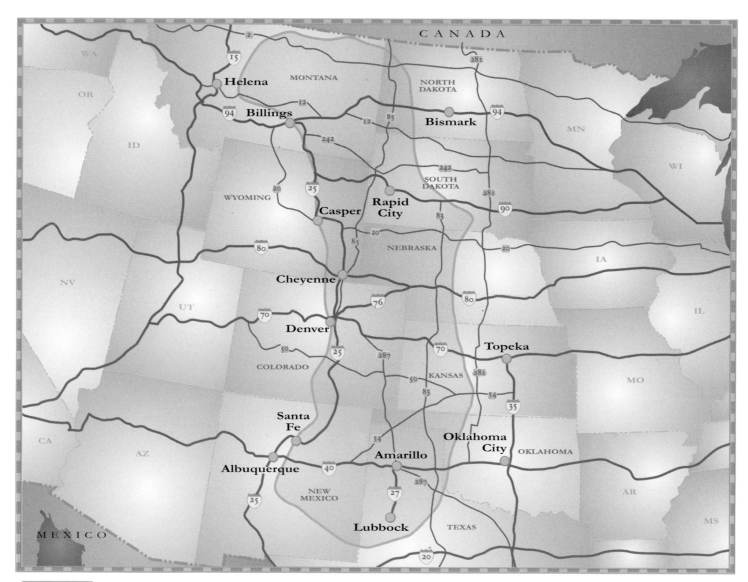

Shading indicates area in which photographs were taken. Map by Kathleen Sparkes.

Left in Time

Steve Fitch

"We think of life as a solid and are haunted when time tells us it is a fluid."

Jim Harrison, The Road Home[1]

ALTHOUGH ONE IMAGE WAS MADE EARLIER, the photography for this book really began May 21, 1991 when I drove east from where I live south of Santa Fe onto the high Great Plains of eastern New Mexico. I was vaguely headed toward the nearly abandoned town of Yeso, which I had passed through several months earlier. I had been intrigued by Yeso because it seemed like some kind of ad hoc museum of abandonment. There were several streets and maybe twenty deserted houses, several empty commercial buildings, an abandoned school, and one very quiet dance hall. There was no one around but one or two houses still looked lived in and there was a functioning post office that was closed for the day. For the most part, however, Yeso sat lost to the world disturbed only occasionally by a car speeding by on U.S. highway 60. Like an abandoned sailing vessel at sea, Yeso seemed to float aimlessly on the open plains.

As I headed southeast near Clines Corners around nine in the morning there were already several large, dark, and nasty thunderstorms surrounding me and it was beginning to rain hard. Not good photography weather, I thought. A couple of miles west of Vaughn I stopped my truck to check out an abandoned building that from the outside looked like an old roadhouse. Like everyone else who has crisscrossed the Great Plains, I had for years been noticing abandoned buildings everywhere but had never really stopped to look inside any of them. I walked around to the back of the building rather quickly because it was raining hard and stepped inside. I was startled and excited to see murals painted on the walls of what was clearly an abandoned honky-tonk. One wall was divided on a diagonal and painted

half white and half black. In the center was a musical note also painted half black and half white [see plate 2]. Right away I knew that I wanted to make a photograph of the wall. The light inside was dark and mysterious and there was water leaking from holes in the roof but I knew it was possible to photograph with my 8" x 10" camera even though, outside, it was pouring rain.

I hustled back to my truck to get my camera and gear and hurried back inside. I was limited as to where I could set up my camera and tripod because of roof leaks but I was able to find a good dry vantage point. It was dark inside and hard to see the upside down image on my ground glass; with difficulty, I was able to frame the picture. My exposure was sixteen minutes long. As the minutes ticked by I studied the rest of the room. I knew there were several more pictures that I wanted to make. Another wall, for example, had a crazy, cartoon-like, nearly obscene painting of a cowboy about to land on a cactus [see plate 3]. Next to that painting was a door covered with sheet metal, marred by bullet holes. In the photograph that I ended up making of that wall, white light bleeds through the bullet holes and around the edges of the door almost as if the light is pushing the door open. This white, molten-like light bleeding into interior spaces would show up over and over in the photographs that I would make like this during the next ten years. I came to think of that light as something almost physical, the powerful and unrelenting light of the high plains, always trying to push its way inside.

Later that same day I drove on another thirty-five miles or so to Yeso. It continued to rain and thunder on and off and the day stayed dark and moody. In Yeso, I made a number of photographs inside abandoned houses.

gone

One was of a couch in a living room surrounded by walls coming apart [see plate 4]; another was of a child's bedroom with airplane wallpaper on one wall [see plate 5]. Over the next several years I would make several photographs of this wall and I came to call it "the airplane wall." On this one day I made eleven photographs, four of which are included in this book. It was a great day in my life and it started my long-term exploration of the high Great Plains.

Back home over the next several weeks I studied the photographs that I had made in Yeso and Vaughn. Four or five were good photographs! For years I had made night pictures and was always interested in the many little events that can occur during a long night exposure. With night photographs I never quite knew what I was going to get. There was a constant interplay between control and a lack of control. And the light in pictures made at night, especially at dusk, was often emotionally as well as descriptively powerful. Because of the low light levels and long exposures the pictures from Vaughn and Yeso were similar in many ways to my earlier night pictures and I became excited about the possibilities I saw for further interior photographs.

But I wasn't sure what the photographs were about. Photographing abandoned buildings can lead to such clichéd photographs, but these pictures didn't seem to fit that mold. And what was it about the content of the photographs that appealed to me? One thing that I noticed about some of the photographs was the way they showed buildings coming apart so that you could literally see how the buildings had been constructed. I was

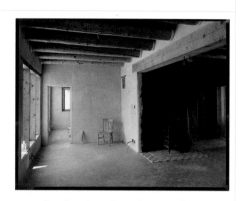

1. Interior view of our house under construction, summer, 1990.

reminded of a Robert Smithson quote that buildings were "ruins in reverse." At this time I was in the final stages of a seven-year building project. Since 1984, my wife and I and our two small sons had been constructing an adobe house during summers on some rural land in southern Santa Fe County. I identified with these earlier builders. They had made great use of materials that were at hand such as rock, mud, sand, gravel, cordwood, juniper, even beer cans—whatever was available nearby. The one photograph from Yeso that shows a couch surrounded by plaster and wallpaper-covered rock walls that are wearing away is a good example of this. The picture looks like a textbook diagram of vernacular plains construction techniques except the building is falling into ruin instead of rising from the ground up.

In July I came back to Yeso and photographed the interior of the abandoned school which, like a number of other vacant schools in eastern New Mexico—had been built by the WPA in the thirties. I also photographed inside an abandoned dance hall that had a half inch of dust on the floor and a piano against the east wall beneath two rows of local ranch brands, painted like pictographs near the wall's top. [see plate 9]. Once or twice a year I would pass through Yeso and I would always check in on this dance hall, sometimes making another photograph. Nothing would ever change. My footprints from the previous visit would still be in the dust on the floor with a new layer of dust covering them. No one else's prints ever joined mine. I was struck by how unvisited many of the buildings I photographed were, how they almost appear to be frozen in time. A house in Ocate, New Mexico was beginning to fall apart and had probably been abandoned for 20 years or

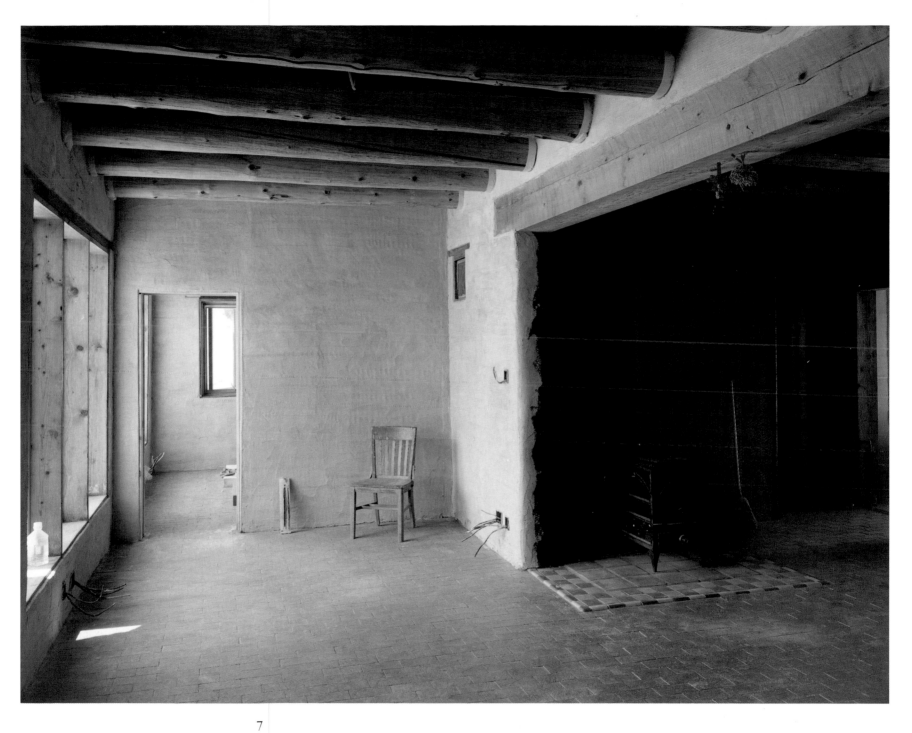

more and yet there was a rather fragile child's drawing still pinned to one wall [see plate 10]. A blackboard in a school in Cedarvale, New Mexico—also a WPA-built school—still had the chalk graffiti that one student had scrawled on the last day of classes before the school had closed for good in 1958. In the gymnasium of that same school beneath a basketball hoop that still had its net was a dusting of snow on the floor, that had blown in through a collapsing wall [see plate 13].

Most of my exploring during the first several years of this project occurred in eastern New Mexico simply because it was close and accessible and I could usually only get away for two or three days at a time. A few times I ventured into western Kansas, southeastern Colorado, and western Texas. At first I made a lot of pictures inside abandoned public buildings. Several years later my focus would shift and I tended to photograph much more in abandoned private houses, though school blackboards remained particularly interesting to me. They were familiar and reminded me of the blackboards I had been taught from in elementary school during the fifties. With their insistent rectangular frames they also reminded me of the many drive-in movie theater screens that I had photographed over the years and of the photographic frame of the camera itself [see figure 2].

I had been thinking of my project as some kind of homage to settlers and homesteaders of the plains. After all, it was humbling to see the remains of earlier people who had tried to settle and stick in a place but who had not succeeded. The blackboard pictures made me question that notion of paying homage. They were familiar to me and seemed to suggest that these places

did not belong to some long-lost group of settlers who I would never know—except perhaps as part of the mythology of the west—because they belonged to a more recent time. I realized that these were the ruins of my own generation and not from the hazy past of mythology. Although the abandonment of the plains had begun during the late 1800s—even as they were being settled—and had continued through WW I and the Great Depression, the abandonment I was photographing was much more recent. The plains were still being abandoned: the process was not finished; it was ongoing. In 2000 and 2001, I would make some photographs inside vacant houses in eastern New Mexico and western North Dakota in which people had been living when I started this project in 1991.

Beginning with the very first photographs that I had made in the honky-tonk in Vaughn, I paid particular attention to the things people did to their walls—what they pinned or painted on them, how they decorated them—and to the artifacts that I found left behind. A lot of this stuff had a fifties look to it and even a Cold War kind of iconography. A school health chart showing two versions of the same teenage boy—one version of him as a "healthy boy" and another of him as a "cigarette smoker"—seemed right out of the fifties [see plate 35]. Another photograph taken of scattered debris on the floor of a house had pages from *Look* or *Life* magazine. Visible on one of these pages is a picture of Senator Joseph McCarthy, "Gunner Joe" [see plate 24]. Another photograph taken in a classroom in eastern Wyoming had a picture of George Washington kneeling to pray. Across the wall from him is a simple outline map of the world that leaves out Africa, Australia and South

America, showing only the outlines of North America and Europe and Asia. It is a perfect depiction of the Cold War standoff [see plate 37].

In a house in western Kansas there was a child's homemade space shuttle left on a kitchen chair [see plate 42] and in a house in eastern Wyoming the walls of another child's bedroom were covered with rocket ships, flying saucers, and space-suited astronauts walking on an extraterrestrial landscape [see plate 38]. I realized that not only was much of this recent abandonment probably fueled by the Cold War—by people leaving the high plains for jobs in Seattle, the San Francisco Bay Area and Los Angeles—but that the spaces they left behind had a kind of spooky post-apocalyptic look to them. One kitchen had plates on the table and dishes in the sink as if the people left one morning intending to return that evening. It occurred to me that this is how our world might have looked if the nuclear war we feared had actually happened. This is how our no longer occupied kitchens and living rooms and bedrooms would appear over time as nature and entropy began the gradual process of reclaiming what we had temporarily claimed.

In 1995 I took the first of several trips north to Wyoming, Nebraska, the Dakotas, and eastern Montana. I had wanted to extend my travels further from New Mexico. By then I realized that the domain of my pictures was the entire "high plains": the region of the Great Plains that extends from about the 100th meridian west to the front range of the Rockies and north from eastern New Mexico and western Texas to eastern Montana and western North Dakota. This is a very large area of land that is always and not inaccurately, being compared to a body of water: an

2. *Screen of a drive-in movie theater in Cheyenne, Wyoming, 1979.*

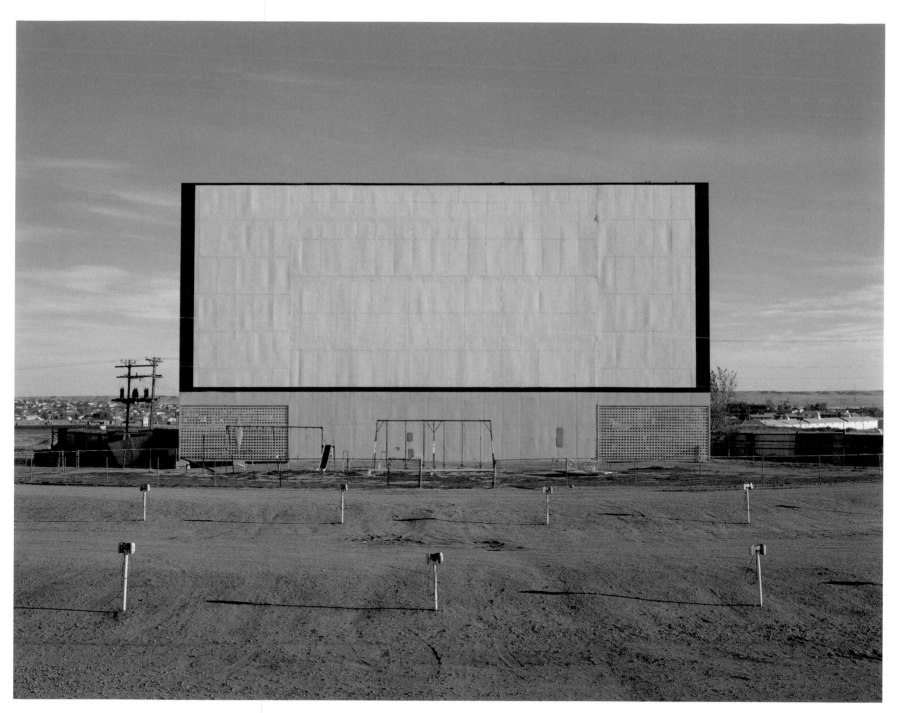

ocean. In one photograph taken inside a house near Roy, New Mexico there is, appropriately enough, a picture of a nineteenth century sailing vessel on high seas next to a window that frames a small section of the high plains [see plate 53]. I had been looking to make an image like this for several years and finally did in 1999.

These longer explorations generally took me in a wandering south-to-north and then north-to-south direction. For a week or two I would be "lost" on the Great Plains. This was different not only from my earlier trips into eastern New Mexico and western Texas—which were west-to-east and back affairs—but also from all the trips I had taken since early childhood back and forth across the plains. It was also different from the general way we as a national culture exist in relation to the Great Plains. Most of the "action" in our culture today exists on the coasts between which we are always crossing the plains either by air or in cars on interstate freeways and mostly in an east-to-west or west-to-east manner. On these longer trips I felt, in many ways, like I was "out to sea" and "away from land" and the landmarks by which I navigated tended to be the places I made pictures in. On any given day I might stop and look inside 20 or 30 buildings. Usually, I only made photographs in 2 or 3. These became my landmarks, the places that anchored me on a map. As such, they became attached to names: Thatcher, Yoder, Ingomar, Gascoyne, St. Phillips, Carlyle, Scranton, Ancho, Modoc, Model, Yeso.

While working on earlier photographic explorations that involved covering territory, something similar had always happened. Beginning in

1971 after I graduated from college, I worked on a series of photographs taken along American highways that became the book *Diesels and Dinosaurs*. An early, key photograph in that project was taken of a billboard on the way to the south rim of the Grand Canyon. It commanded simply: "FILM Hit the Rim Loaded." Much like the photographs that I made in the honky-tonk in Vaughn that started this project, "Hit the Rim Loaded" launched *Diesels and Dinosaurs* [see figure 3]. Later, I would make many pictures of billboards, signs, and neon signs as well as of motels and drive-in movie theaters. These photographs were taken all over the United States and became the landmarks that connected me to our country's geography. They served to anchor me both physically and psychically to the American landscape. The pictures I made for this book did something similar: they helped orient me on the high Great Plains and give me my bearings in an often disorienting landscape.

Televisions began to appear in my photographs in 1998 and 1999. I don't know why they hadn't been there earlier, since I had found television's abandoned in houses along with other appliances like stoves, refrigerators, furniture, typewriters, record players and even pianos and pool tables. I guess I just didn't pay attention to them until the day I made a picture of a kitchen with a Sylvania TV on the floor next to a box of canning jars [see plate 48]. That photograph is indicative of how I worked. I would often tend to focus on a particular artifact and then become preoccupied with it over a period of time. Part of this was due, I think, to a kind of vestigial hunter and gatherer instinct that photography feeds off so well. We tend to collect as a hedge against the future. First I photographed blackboards, then televisions.

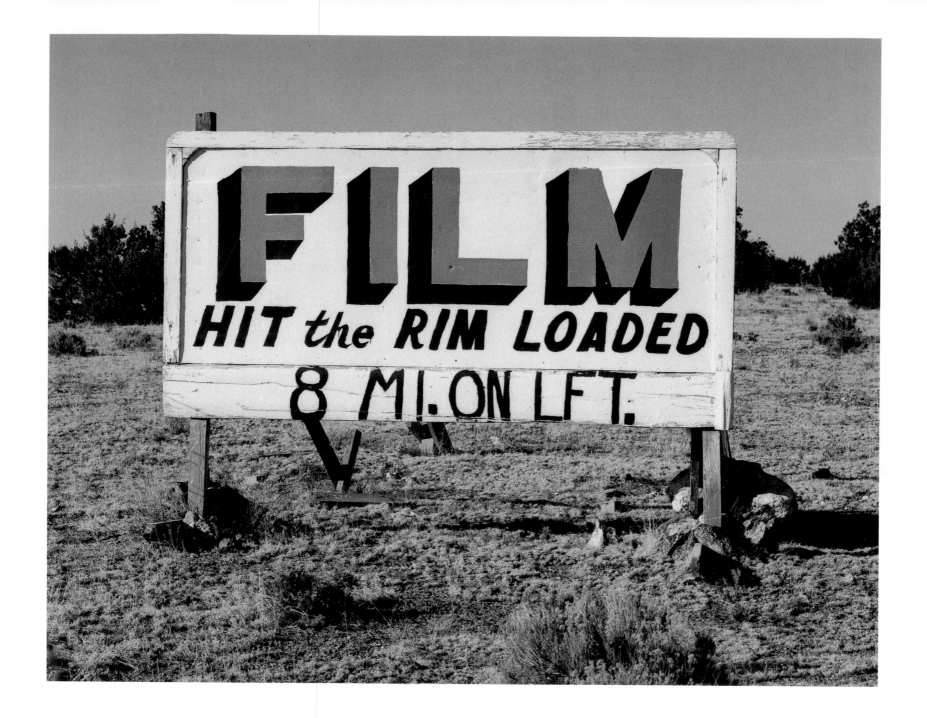

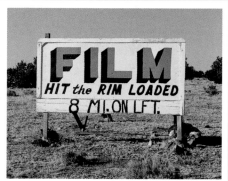

3. Billboard, Highway 180, Grand Canyon, Arizona, 1972 from Diesels and Dinosaurs, Long Run Press, *Berkeley, California, 1976.*

Blackboards seemed to represent an earlier kind of frame perhaps symbolic of the mechanical industrial age. Televisions also have frames but they're electronic with rounded edges, indicative of the electronic industrial age. The TV was really an artifact that drove home the "recent-ness" of the abandonment that I was photographing. I was nine years old in 1959 when my family got its first TV and I was astonished to see them as artifacts in abandoned buildings. While I was growing up, televisions had been the paragon of "modern," and here I was finding them broken and unused along with empty jars and tin cans and flyswatters.

Around this same period, 1997 to 1998, I discovered rooms with clocks and calendars in them: human chronological markers. Clocks were in some of my photographs back in the 70s and now they were showing up again. In the photograph of the motel in Deadwood, South Dakota from *Diesels and Dinosaurs* there was a clock I could see through the window. The time was 8 hours and 46 minutes; the second hand blurred for about a second— the length of my exposure—at around 25 seconds after the minute [see figure 4]. I took particular pleasure in a photograph that not only told me what time of day it was taken, but also how long the exposure had been. The clocks in the photographs here can't do that.

Even though some of them were still plugged in—the clock in the kitchen in the house in Ingomar, for example—the hands hadn't moved for a long time [see plate 50]. As I stood next to my camera and waited out the eight-minute exposure, it was obvious that the clock in Ingomar was inert. One version of time had ceased to exist in this house. That same house in

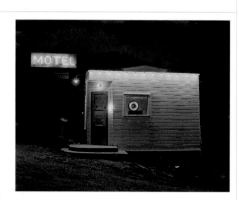

4. *Motel, Highway 85, Deadwood, South Dakota, 1972 from* Diesels and Dinosaurs, *Long Run Press, Berkeley, California, 1976*

Ingomar also had a calendar nailed to the living room wall just around the corner from the clock [see plate 51]. It hangs opened at August, 1974, the same month and year that I had been working at a state fair in Maine and that Richard Nixon had resigned as President of the United States. This calendar dated the abandonment of this house as surely as radiocarbon will date an Anasazi ruin in the Southwest. Another house near Haley, South Dakota had four calendars in the living room, one on each wall and all stopped at September, 1963. I call it the calendar house.

The houses with the clocks and calendars and televisions in them were among the "freshest" of any I had photographed. They were "ripe"—that is, they seemed to be more recently abandoned than the places that I had, up until then, been photographing. There was a lot more stuff left behind in these houses, including books, blankets, pillows, clothes, shoes, letters, school papers, toys, bank receipts, flowers, arts and crafts work, tools, jars and cans of food, dishes and napkins and—most surprising of all—photographic snapshots. The places often looked like crime scenes with material scattered all over the place as if the house had been ransacked. As a result, my photographs sometimes reminded me of crime scene photographs. I would stare at such a photograph and think that the picture looks the way it does because of a long chain of events. "Like a crime photo, there is evidence of cause and effect depicted here."

I would often witness these events especially the more common, repetitive ones. Since my exposures were anywhere from one to thirty minutes long, I spent plenty of time waiting them out. In fact, this waiting had a

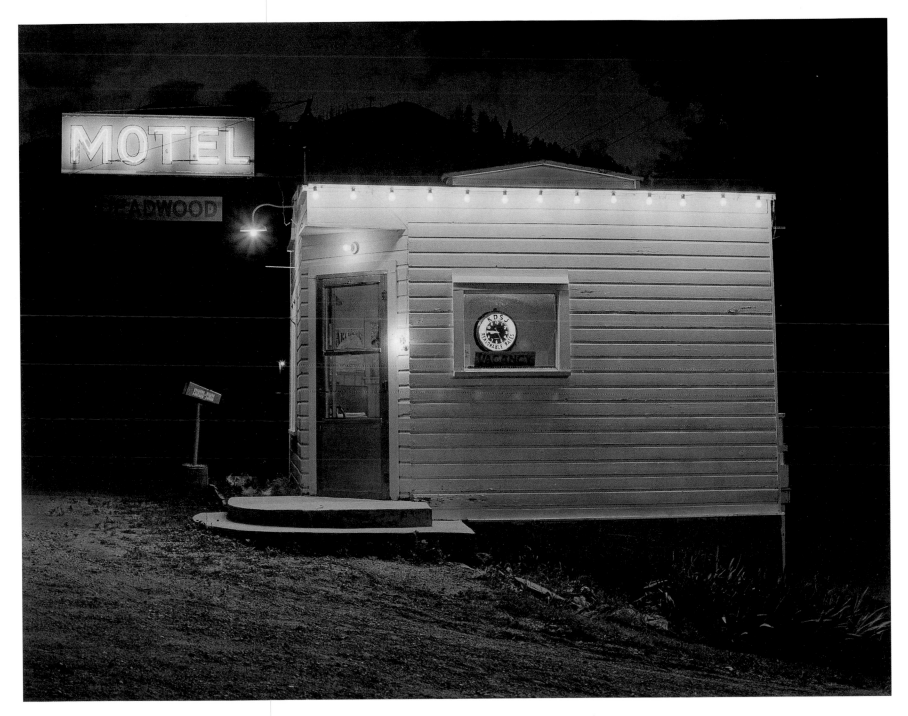

zen-like feel to it—I was literally standing inside my exposure—and I often enjoyed the duration. It brought my life to a standstill as if the long exposures were a way to briefly stop time. Sometimes I could move around the building that I was in and explore for other pictures to make. Other times I had to remain perfectly still—so as not to shake the camera—and just observe what was going on around me. It was almost never quiet. Usually, the wind was blowing, causing doors to creak and bang and windows to rattle. Almost always there were birds around going about their business of building nests, tending to their young, and making strange noises. Occasionally, there was a skunk or other rodent digging around under the floors. Once a bird flew through a glass windowpane with a burst of explosive energy that scared the hell out of me. I jumped and shook the camera as a result.

From moments like these, it was clear to me that I was an intruder, a trespasser. Birds and other animals had made these buildings theirs and I was invading their space. Since I almost never asked permission to enter these buildings—there was almost never anyone around to ask—I knew that I was also trespassing into other peoples' spaces as well. I was a voyeur. Sometimes I felt guilty about this because many times the houses felt so tangibly personal. Those marks on the refrigerator door were a family's grimy fingerprints layered over perhaps a generation of time and what business did I have to be inside here photographing them? But I also, in a funny way, felt that it was my duty to make these photographs. That somehow I had been "called" to do it, that I was on a mission.

Through my act of witnessing these scenes and these places I was giving them lasting meaning and importance. If I was not paying homage to the early settlers then perhaps I was paying it to the passage of time.

In the summer of 1999 I visited the Fitch family farm in South Dakota where my father grew up. The land had been homesteaded in 1873 by my great-grandfather and it's still farmed by my cousin but the original farmhouse now stands empty. It was strange to explore the rooms of this old house because, unlike the hundreds of other buildings that I had checked out over the previous years, I knew the people and the stories associated with this one. As a boy growing up on the West Coast of the United States I had visited the farm many times on family vacations. I knew the bedroom that had been my father's and which part of the house was the original homestead and which part had been added. In an upstairs bedroom amidst the clutter of books, magazines, clothes, and miscellaneous travel souvenirs I found a second grade school photograph of myself. In an adjacent closet hung a dress that had belonged to my aunt, Dorothy. In this building I was not a trespasser as I had been in all the others but the clocks and calendars had stopped here like they had in my other plains photographs. Personal connection and familiarity surrounded me but that was not enough to restart those clocks. Time was moving but it needed a different recognition than that provided by devices like clocks and calendars.

If one imagines a time-lapse movie filmed from a bird's-eye view onto the Great Plains one would see various waves of human occupation washing across the landscape during the past fifteen thousand years. Beginning

with the early paleohunters, these occupations have all left their artifacts and ruins upon the earth. The most recent wave of human occupation began in the second half of the nineteenth century and consisted mostly of settlers of European ancestry who largely displaced the indigenous plains peoples. Encouraged to settle and farm the semi-arid high plains by the Homestead Act and promotional activities of various railroad companies, these new inhabitants began to abandon the plains from the very moment they arrived to settle them.

This abandonment was accelerated by the Great Depression of the 1930s and in most areas of the high Great Plains, has continued unabated. During World War II and the following Cold War, people left the open plains for jobs on the coasts and in cities. The exodus continues today. Left behind are the shells of former lives: houses on farms and in towns, schools, churches, bars, honky-tonks and dance halls.

My photographs were made inside these shells and represent a moment in time at the junction of three histories on the Great Plains: natural, cultural, and personal. I recognize the rooms, artifacts and blackboards in these photographs because during the 1950s and 1960s I was raised in spaces like these and taught from similar blackboards. I also recognize the nightmarish, spooky look these pictures have because it resembles how I imagined the remains of our world might look if the Cold War ever did produce its nuclear war.

Scattered across the plains, these interior spaces exist like countless individual museums dotting the landscape. They are, in fact, the most

gone

private part of the landscape. However, the exhibits inside—unlike the clocks and calendars—are not frozen in time but are instead in a state of constant change. Like crime scene photographs these pictures are loaded with the traces of innumerable past events that have accumulated over time to shape a detailed scene that I discovered and photographed. Like a detective and a witness, I present these pictures as the secret evidence of one phase of a shifting human landscape glimpsed for a brief instant on a scale of geological time.

Steve Fitch is an assistant professor at the Marion Center for the Photographic Arts at the College of Santa Fe.

Note

1. Jim Harrison, *The Road Home* (New York: Washington Square Press, 1999), 13.

gone

Time Travels on the Prairie:

Steve Fitch's Archaeology of Abandonment

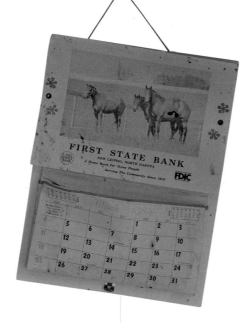

Kathleen Stewart Howe

For every surviving ranch, I passed a dozen ruined houses. The prairie was dotted about with wrecks. Their windows, empty of glass, were full of sky. Strips of ice-blue showed between their rafters. Some had lost their footing and tumbled into their cellars. All were buckled by the drifting tonnage of Montana's winter snows. Their joists and roof beams warped into violin curves. Skewed and splayed, the derelicts made up a distinctive local architecture.

Jonathan Raban, Bad Land: An American Romance, 1996

S OMEWHERE NORTH OF SCRANTON, NORTH DAKOTA, ON JUNE 9, 2000, Steve Fitch stands motionless in someone's bedroom. He doesn't know the people who lived there, although if they were to walk into the room he'd probably recognize them from the photograph on the wall, perhaps made on the occasion of their fiftieth wedding anniversary. The place is abandoned; it has just begun the slow, entropy-driven slide into ruin that marks so many other houses and schools and dance halls across the Great Plains. The signs of sudden departure are evident, yet it still seems possible that someone may return to finish packing the belongings on the bed and reclaim the picture on the wall. Fitch knows from the experience of his ten-year odyssey, visiting and photographing the abandoned structures that dot the Great Plains, that the owners probably won't be back. There is something profoundly sad about a departure that leaves behind mementos such as family photographs. It speaks to a deep sense of failure as Kathleen Norris noted in Dakota:

> In my area, more than one family has abandoned such evidence of their past; they've walked away from farmhouses and moved to town, leaving behind not only the oak furniture but old china and handmade quilts, even family photographs. The truth was so painful it literally had to be abandoned.[1]

This room, over time, will come to resemble other spaces abandoned decades earlier, such as the living room in a house near Aguilar in eastern Colorado that Fitch photographed five years earlier. In both pictures, ordinary domestic spaces—built as refuges from the overpowering expanse of sky and

gone

land that define the mid-section of this continent—slowly lose their integrity. The house in Aguilar is near the end of that fight, gradually filling with drifts of leaf litter and animal droppings, shredded wallpaper and insulation. The roof is gone, exposing the room to the extremes of sun and snow that characterize the knife's edge of survival on the Great Plains. Surprisingly, a window remains intact, a poignant reminder of the settlers' attempt to contain and order the immensity of horizon and prairie that surround the house. O. E. Rolvaag described the sensory impact of life out on the plains: "It is hard for the eye to wander from skyline to skyline, year in and year out, without finding a resting place."[2] These tightly closed, small-windowed houses on great sweeps of land were a respite from space, a place to rest the eye on things, near and familiar. In the bedroom near Scranton, the pressure of light at the curtained window presages the force that will slowly absorb this place, taking with it the pocket book and photograph that marked a life. These domestic spaces partake of the nature of ruins—human handiwork inexorably pulled down by the forces of time and nature—and the muddled disorder of the refuse heap. The photographer/archaeologist is interested in both.

Steve Fitch's long photographic journey through derelict structures on the American Great Plains resonates with what we could call an archaeology of abandonment. The systematic construction of the record of a ruined past proclaim a neutral archaeological document of significant ruins. Yet Fitch's photographs of vacant, foreclosed interiors offer up the refuse of a time not distant enough to have acquired the numinous sense of the past that the truly ancient possess. He acknowledges, "These are the ruins of my own genera-

tion." The abandoned TV sets, the school blackboards, and rocket ship wallpaper were part of growing up in the United States in the 1950s.

Physical traces of the past are all around us. What leads one to identify some traces as relics and others as rubbish varies with environment and history, with individual and culture, with awareness and inclination. From the Enlightenment on, monumental ruins have been read as metaphors for the transience and persistence of human history. Yet human presence is more frequently inscribed on the land in ordinary domestic and industrial constructions, structures not usually accorded the respect of ruined monuments. These remnants of everyday existence seem to imply not the grand march of history, but the fragility of the social order.

A member of the Society of Commercial Archaeology, Fitch is accustomed to thinking of our own industrial, retail, and agricultural "stuff" as part of the archaeological record, elements of material culture as important as the trappings of religious or spiritual life. Indeed, Elizabeth Hardwick reminds us that ordinary objects through long association and use acquire a deeply personal, almost spiritual, component: "What is an old appliance except a tomb of sorrow, a slab of disappointment, a fraud not really acknowledged but kept around mournfully, a reminder of life's puzzling lack of accommodation?"[3] Fixing relics of the past on photographic paper doesn't repair them, but it does give the illusion of reclaiming them from the effects of time.

Fitch's project continues photography's long engagement with recording and preserving the physical remnants of the past. In fact, it is no exaggeration to claim that photography and archaeology were conjoined from the first

gone

official proclamation of a photographic process. Photography was proposed as part of the archaeological record when François Arago, Permanent Secretary of the French Academy of Sciences, announced the successful coupling of lens and chemistry to produce permanent images, first to the French Chamber of Deputies and then to a joint session of the scientific and artistic establishment. In this—photography's introduction to the world—Arago emphasized the utility of the new medium for recording the remnants of antiquity, specifically the hieroglyphic texts on Egyptian monuments.

> While these pictures are exhibited to you, everyone will imagine the extraordinary advantages which could have derived from so exact and rapid a means of reproduction . . . everybody will realize that had we had photography in 1798 we would possess today faithful pictorial records of that which the learned world is forever deprived. . . . To copy the million[s] of hieroglyphs which cover even the exterior of the great monuments of Thebes, Memphis, Karnak, and others would require decades of time and legions of draughtsmen. By daguerreotype, one person would suffice to accomplish this great work successfully.[4]

From the start, photographers were archivists of their world, employed as record keepers of the soon-to-vanish (the architect Viollet le Duc commissioned daguerreotypes of Notre Dame de Paris in 1842, before beginning its restoration) and recorders of the newly uncovered (Layard daguerreotyped the excavations of the palace walls of Nineveh). The earliest cameramen set up their tripods and aimed their lenses at Assyrian ruins as they emerged from the

sands, at medieval cloisters in Europe, at mortuary monuments along the Nile, and at jungle-covered temples in Mesoamerica. The French Historic Monuments Commission, formed in 1832 to conserve France's architectural patrimony, commissioned five photographers as the Missions Héliographiques in 1851. Assigned to record cloisters, cathedrals, and castles, their work is the first official government photographic survey of antiquities.[5] A string of photographers beginning with Maxime Du Camp in 1849 answered Secretary Arago's call to photographically preserve the ancient ruins of Egypt.[6] In 1855 August Salzmann photographed the architectural palimpset of Jerusalem to provide what he called "brute facts" to support the archaeological findings of his sponsor.[7] A number of private and government commissions sent photographers throughout the Indian sub-continent to photograph sculpture, architecture, and ancient cave sites. Désiré Charnay began photographing the Mixtec ruins at Mitla in Oaxaca, Mexico in 1859.[8] It is no exaggeration to say that in the last half of the nineteenth century anything with a claim to antiquity was recorded photographically.

There is, however, more to the association of archaeology and photography than early photography's manifest utility as recorder of static ruins. The formal qualities of the photograph—the device of framing and recording discrete moments—emphasize fragments of the past, as does the discipline of archaeology, and, for that matter, the functioning of memory. It is the curious fly in amber quality of the photograph—the unique conjunction of place and subject at a particular moment—that emphasizes photography's connection with the study of the past. The photographic frame contains a frozen section

that can be studied to derive descriptions of a precise moment and from which one may construct narratives about the people and objects recorded and the relationships between them. This quality of memorial also connects photography to transience—it is the nature of the photograph to preserve, as it underscores the recognition that something that existed at the moment the shutter was released is destined to dissolve into nothingness.[9] Arago's enthusiasm for photographic records of Egyptian antiquities was not a recognition of the awful permanence of those monuments, but an understanding of the necessity for a salvage operation to preserve the rapidly disappearing texts of a vanished civilization.

The temporal quality of the photograph is bivalent. It is a record of the visible traces of the past and an artifact of its own particular moment. The early photographers who recorded the ruins of antiquity provided documents from which the nineteenth century, newly engaged in plotting a history of humankind, could begin to construct the science of archaeology. Today we look at those early photographic documents as archaeological artifacts of nineteenth-century intellectual history.

Steve Fitch's photographs are direct descendants of the early appreciation of the utility of photography for recording ruined remnants of the past. But as a photographic collector of material culture, a process that gives rise to the construction of typologies—in this case a typology of interiors of abandoned structures on the Great Plains—he is of his own cultural moment. It is a moment that began in 1957 when German photographers Hilla and Bernd Becher started their photographic archive of industrial structures and workers'

housing. The subtitle of their first book, "A Typology of Technical Constructions," reveals the didactic and expository nature of the project: "to collect the information in the simplest form . . . and to give a clear understanding of the structures."[10] It also visually preserved a specific moment in the history of industrialization as the structures they recorded began to disappear. The Bechers were among the first contemporary artists and photographers who echoed the historical precedence of Eugène Atget and Walker Evans in creating specialized photographic archives a compelling strategy as twentieth-century culture replaced itself at an ever-increasing pace. As James Lingwood pointed out, "the typological has long been a construction against loss."[11] They were followed by projects as diverse as Lewis Baltz's compendium of pre-fabbed spaces in the New Industrial Parks and Park City series, and Roger Mertin's series of shabby Christmas trees in lower middle-class homes.

A typology, simply put, is a collection of members of a common class or type. It is assembled by observation and discrimination, activities that precede and inform the enterprise of collecting, grouping, and naming. This type of ordering activity is more often associated with the sciences than with the arts. Typologies reveal characteristics shared by objects and throw into sharp relief minute differences within a class that make a particular object unique. Similar yet distinct items engage in a dialogue that defines what marks their inclusion in a class and how things within the class may vary. In the best typologies, slight differences among similar things seem more apparent, more arresting. When the collection is formed from elements of material culture, the accumulated visual weight of mundane, manufactured things that otherwise might have been

overlooked allows us to recognize the true strangeness of the things we make. Who can look at industrial architecture in the same way after seeing the Bechers's visual collections of blast furnaces, water towers, and mine heads?

Photography is uncannily suited to the construction of typologies. The photographic act removes fragments of the physical world from the flow of time, isolates them from continuous space, and preserves them for comparison and study. At the turn of the century, Eugène Atget compiled an ever-expanding dossier of Paris arranged by type—parks, streets, architectural details, shop windows, interiors—and in so doing he created an extensive archive of the material culture of Paris at the beginning of the twentieth century. It is an archive of the past, containing the preserved remains of a moment when Paris was changing. Certainly he understood his work in those terms; on the back of many of his prints he wrote, "This will disappear." It is this sense of the archive, not the individual print that is the appropriate framework for understanding Steve Fitch's collection of abandoned structures on the Great Plains.

Fitch has been fascinated by photographic typology since he picked up a camera in high school and began making pictures of the hop kilns around his rural community, his first systematic photographic project. His mature work returned to the visual collection of objects, elements of roadside Americana (drive-ins, painted signs and murals, and the peculiarly American stars of roadside pop culture, the dinosaur and the diesel). Diane Arbus located Walker Evans's photographic power in "a profound historical empathy which permitted him to see things around him as destined for extinction and to photographically preserve them as prospective relics."[12] It is not surprising then, that

gone

in conversation with Steve Fitch, he singles out Evans's photographs of rural interiors as the wellspring for his own photographic praxis of ordering and preserving the past.

Evans with his "profound historical empathy" and Atget's notation of the imminent disappearance of places and things are closer to the core of Fitch's work than the dispassionate catalogues of Baltz and the Bechers. A typology of abandonment, when the things abandoned are from one's own childhood, cannot remain cool and uninflected. Fitch is there in those derelict spaces recording elements that might have been transplanted from his home, his room, his school. He has sought out those spaces and photographically preserved their contents. Fitch has been forming his archaeology of abandonment for over ten years, criss-crossing the Great Plains in his search for decaying interiors within the detritus of his own past.

A photograph is an event before it becomes an object. It may unfold in a split-second—a fact that has obscured the quality of event embedded in every photograph—or it may be the culmination of lengthy preparations, both physical and intellectual. The process of defining and pursuing the photographic project, choosing and framing the view, and making the images may occupy a photographer for years. The process comes together in the moment in which the photographer releases the shutter and lets light accumulate on film. For the photographers working in Egypt in the first decade after photography's inception, the quality of event seems readily apparent to us, more so than that of contemporary photographers who work in our age of instant point and shoot cameras. The earlier photographers' arrival in the Middle East opened them to

radical changes in light and sound and smell from what they knew in urban Europe. The project of finding a boat and crew for the Nile journey, and their careful transportation of fragile optics and containers of chemicals all contribute to our understanding of that photographic process as a movement through time and geography. Once on site, setting the camera might consume the better part of a morning. And then the success or failure of the project hung in the balance as the photographer opened the lens and waited with watch in hand, counting the minutes of the exposure. Gustave Flaubert, traveling with photographer Maxime Du Camp in Egypt in 1849–51, confided in a letter to his mother, "I fear young Max will crack up under the strain."[13]

We can get a sense of the event of the exposure from the notes of Félix Teynard who photographed along the Nile two years after Du Camp. His caption for a view of the ancient Roman fortress of Primis evokes the long minutes of the exposure in which the photographer, standing silently by his camera, becomes a stilled receptor of sense impressions of the place:

> Within its fortified enclosure wall, still completely standing, one finds streets, houses, ruins of Roman columns, Christian crosses, Moslem mosques, but one sees no modern dwellings, no trace of man, no domestic animal either in this old city or its environs. The absolute silence is disturbed only by the cries of the jackal.[14]

Looking at Teynard's photograph and reading his words, we can recover the sensory event that was the exposure as he registers a profound stillness articulated by the sound of the wind through deserted streets and the cry of a lone jackal.

The photographs made by Steve Fitch are not the images of a moment but exposures of ten, twenty, thirty minutes. Standing within the exposure, not moving lest a weakened floorboard shift under his weight and jar the camera, Fitch is forced into a peculiar intimacy with the space. His gaze wanders across the things left in the room, arrested by a scrap of note or a schoolbook identical to one from his childhood. The sound of the wind whistling across empty miles of land fills the minutes of the exposure. As Fitch looked at his photographs with me, he recalled times when, as he stood silently timing the exposure, the physical force of the light-filled space outside of the room seemed a palpable, almost inimical, presence pressing against the shell of the structure. It is a sense shared by the narrator of Barry Lopez's short story "The Deaf Girl," describing a three-day stay in Gannett, Montana:

> Remembering those days now, it occurs to me that outside of ordinary noises—a door closing, an engine starting, the ticking of wood cooling in the hotel's walls in the night—one sound hummed beneath it all, the streaming down of light from the empty sky.[15]

What can Félix Teynard and Maxime Du Camp, working 150 years before Steve Fitch started criss–crossing the Great Plains, tell us about Fitch's project? In a sense, it is necessary to return to the projects of those two earlier photographers to recover the sense of geography and scale that is appropriate to Steve Fitch's archaeology of abandonment. The archaeological component signals us to look at the dimension of time encapsulated in the photographs—to see the photographs as records of the past, the time spent collecting the

sites and making the photographs, and the length of the exposure—but there is a spatial component to this project. It is as much about geography as it is about time. The time spent on this project translates literally into thousands of miles spent crossing and recrossing this vast region. The photographs record "real" distances covered on gravel roads, in week–long excursions, moving from one small town to another. There is a corresponding psychic distance from where he lives now, in a house he built with his wife near the college where he's a member of the faculty, to where he was raised and where his grandparents' farmhouse sits empty. These abandoned interiors seem to be next–door neighbors, connected by their proximity within a book or on gallery walls; in reality, they are scattered across thousands of square miles and years of experience.

Fitch doesn't translate the distances that engulf the abandoned structures he photographs into photographic views of the open prairie. The vast geography is not explicit in the pictures but rather is implied in the small interiors. Houses are closed tight, windows covered against the immensity of that light-filled space. In photograph after photograph, people chose wallpaper, painted murals, and hung pictures that replaced the scene outside their doors with different, more hospitable places. "Mural of a homestead in a boy's school in Pettit, West Texas, March 14, 1994" records an idealized view of what a homestead could or should be, rather than the bleak reality of west Texas. Patrons drinking at the "Bar in Gascoyne, western North Dakota" could rest their eyes on a lush woodland meadow with two fat deer. The Hop-a-long Cassidy wallpaper in "Bathroom in a house in Model, southeastern Colorado" offered a

green fantasy of life on the range. In many houses, derelict televisions hold court in living rooms, the sixties' eye onto different worlds. "Living room in a house near Ludlow, eastern Colorado" holds two televisions, one crowned with antlers instead of the "rabbit ears" ubiquitous to areas with poor reception.

Fitch speaks of his connection with these places. "I recognize the rooms, artifacts, and the blackboards in these photographs. During the fifties and sixties, I was raised in spaces like these and was taught from similar blackboards."[16] This is connection enough, but toward the end of a long conversation about this project, Fitch tells me about visiting his grandparents' farm on the eastern edge of South Dakota. As in many of the places he's photographed, the old folks have died and, although the land is still farmed, no one lives in the house. Standing in the abandoned home he played in during long childhood summers, he saw his grade school picture, now an artifact in one of his self-described archaeological sites. He made a few photographs in this place, so familiar from childhood memory but now made strange by its abandonment and decay. As I write this, he's still uncertain if he will include any of those photographs in this book, or if he will exhibit them. He says they're good pictures. "But, you see, they're further east than 100th Meridian," he explains, "and so don't fit the parameters."

Even without a personal tie, it is difficult not to be moved by these abandoned sites, bitter endings to hopeful beginnings. Jonathan Raban, an Englishman newly settled in Seattle, became fascinated by the vast region, its failed homesteads and the tough "stickers" who continue to wrest a living from the land. In writing about the cycle of hope and despair and retelling the

stories of those who stayed and those who moved on, Raban confessed, "I took the ruins personally."[17] It would be difficult not to take the disappointment distilled in these photographs of abandoned interiors personally.

The impact of Steve Fitch's careful visual excavation lies in the tension between his use of the neutral archaeological record and carefully constructed typology and the emotional response elicited by an abandonment that is so close in time to our own lives. The stories of loss and persistence are personal stories. They resonate with us because they embody the dark side of our contemporary transience. David Lowenthal took a line from a nineteenth-century novel, "the past is a foreign country—they do things differently there," as the title for a book that explores the contemporary fascination with the past. He agrees that indeed the past is a foreign country but finds that its "features are shaped by today's predilections, its strangeness domesticated by our own preservation of its vestiges."[18] Yet, sometimes we realize with a chilling sense of connection that the past is not so foreign after all. We are part of it; we continue to act out the hopes and disappointments contained in its lost spaces. Steve Fitch's visual archive of the recent past doesn't domesticate that past; rather, the ordinary domestic spaces he records reveal a deep strangeness at the core of our own present.

Kathleen Stewart Howe, Ph.D., is curator of prints and photographs at the University of New Mexico Art Museum. She also teaches in the department of art and art history at UNM.

gone

Notes

1. Kathleen Norris, Dakota (New York: Houghton Mifflin, 1993), 85.

2. O. E. Rolvaag, *Giants in the Earth* (New York: Harper and Brothers,1929), 424.

3. Elizabeth Hardwick, "In Maine," *New York Review of Books*, 1992, 4–6.

4. Arago made the first official statement on 3 July 1839 before the French Chamber of Deputies when he confirmed that Daguerre had successfully accomplished the eagerly pursued goal of fixing permanently the image created by a lens. On 19 August, he read Daguerre's technical description to the joint session of the Academies of Science and Fine Arts. In both venues he repeated the connection between the new photographic process and the study of Egyptian antiquity. The entire text of Arago's report is reprinted in *History of Photography*, Joseph Marie Eder, trans. E. Epstein, (New York: Columbia University Press, 1945: reprint ed. 1972), 234–35.

5. For a discussion of the early connections between archaeology and photography, see Barry Bergdoll, "A Matter of Time: Architects and Photographers in Second Empire France," in *The Photographs of Edouard Baldus* (New York and Montreal: Metropolitan Museum of Art and Canadian Centre for Architecture, 1994). For the cultural context in which the Missions Heliographiques functioned and the association of early photography and archaeological interests, see Eugenia Parry Janis and Andre Jammes, *The Art of French Calotype* (Princeton,N.J.:Princeton University Press, 1983).

6. For a general discussion of photography in Egypt, see my *Excursions along the Nile: The Photographic Discovery of Ancient Egypt* (Santa Barbara, California: Santa Barbara Museum of Art, 1993).

7. Salzmann's photographs were published in 1856 as *Jerusalem, vues et monuments de la ville sainté de l'epoque judaïque, romaine, chrétaine, arabe, explorations photographiques*. The most complete treatment of Salzmann's photographs within the context of archaeology is Françoise Heilbrun, "Photographies de la Terre Sainté par Auguste Salzmann," in *F. de Saulcy et le Terre Sainté* (Paris: Ministère de la Culture, 1982). For a critical reading of Salzmann's project see Abigail Solomon-Godeau, "A Photographer in Jerusalem, 1855: Auguste Salzmann and His Times," in *Photography at the Dock: Essays on Photographic History, Institutions, and Practices.* (Minneapolis: University of Minnesota Press, 1991) 150–68.

8. Desire Charnay, *Cités et ruines américaines* (Paris: Gide, 1863).

9. Roland Barthes, *Camera Lucida: Reflections on Photography*, trans. Richard Howard (New York: Noonday Press, 1981).

10. Hilla and Bernd Becher, *Anonyme Sculpturen: Eine Typologie technischer Bauten,* (Düsseldorf: Art Press Verlag, 1970).

11. James Lingwood, "Working the System," in *Typologies: Nine Contemporary Photographers* (Newport Beach, California: Newport Harbor Art Museum, 1990), 91.

12. Diane Arbus, "Allusions to Presence," in *The Nation*, 11 November 1978.

13. Gustave Flaubert, "Letter to his mother of 15 April 1850" in *Oeuvres completes de Gustave Flaubert*, cited in Howe, *Excursions along the Nile*, 26.

14. Félix Teynard, *Egypte et Nubie* (Paris: Goupil et cie., 1858), cited in Kathleen Stewart Howe, *Félix Teynard: Calotypes of Egypt* (New York: Kraus, Hershkowitz, and Weston, 1992), 78.

15. Barry Lopez, "The Deaf Girl," in *Light Action in the Caribbean* (New York: Vintage Books, 2001), 64.

16. Steve Fitch, artist's statement accompanying the exhibit "The Archaeology of Abandonment: Photographs from the High Plains."

17. Jonathan Raban, *Bad Land: An American Romance* (New York: Random House, 1996), 10.

18. David Lowenthal, *The Past is a Foreign Country* (Cambridge, England: Cambridge University Press, 1985), xvii.

Homesteads and Heartaches:

A Photographic Journey Through the Failed West

Evelyn A. Schlatter

I took my family in my own wagon, it was the 17th day of August when we road [sic] from Peabody onto the land, 14 miles northwest. so we rode in the deep grass to the little stake that marked the spot I had chosen. When we reached the same I stopped, my wife asked me, why do you stop? I said we are to live here. Then she began to weep.

—*Jacob A. Wiebe, Kansas, 1874[1]*

We left like people fleeing a disaster: boxes of our possessions all over the floor, the kids' books still in their shelves, the flowers in the garden abandoned to wither.

—*Alison Clement, Oregon, ca. 1980s[2]*

LOOKING ACROSS THAT HUGE EXPANSE, WITH REALLY NOTHING OF HER previous life to give her comfort, Jacob Wiebe's wife vented her distress at the prospect of making a go of it on an empty stretch of land. A hundred years later, writer Alison Clement wrote of *her* distress about having made a go of it on a patch of wooded land and failing. So desperate were she and her family to be done with the constant work and difficult circumstances that came with an isolated cabin existence in an Oregon forest that they just pulled stakes, intentionally leaving behind a slew of personal possessions that had become imbued with the essence of failure and could only serve as a reminder of a painful few years. They just wanted to be gone.

That's the story of the West. Come and go, boom and bust. Here, photographer Steve Fitch provides us a story that we do know but that maybe we haven't really thought about. Everyone knows the postcard photos of slowly collapsing abandoned nineteenth- and early twentieth-century homes and other buildings, either positioned against a backdrop of mountains or a horizon of plains. They're picturesque, maybe even artistic or "quaint" and because they're exterior shots, we're protected from the realities of the lives that were lived within them. We're at a comfortable tourist distance, separated not only by the nature of the medium, but also by the rough wooden walls of each structure. An exterior, distant shot of an abandoned home, school, or church doesn't allow us to step through the door or look through the window to see the vestiges of the former inhabitants. It doesn't offer us a connection to a real past. As outsiders, we see only a nice view with a tired old building.

But with the photographs that Fitch presents here, we are forced to become insiders, to walk among people's private rooms, see their private things, and view their private thoughts in things like a picture on a wall or a made bed. Fitch has gone beyond the superficial postcard shot of abandoned western structures and he takes us inside the failures, inside the ended dreams within those silent walls. The effect is akin to standing in a cemetery, at once overwhelming and maybe uncomfortable. For death and failure are two things that Americans don't want to accept but they are nevertheless an intrinsic part of the West, and not entirely limited to lone homesteads on windswept prairies.

Fort Union sits about 135 miles north-northwest of Albuquerque. It's now a National Park Service-managed historic site, part of the Santa Fe Trail. You can tell it was of substantial size from the numerous stone chimneys of the officers' quarters that stand in straight rows along the perimeter of the original boundaries. Complete structures don't exist anymore; they've been reclaimed by the New Mexico plains, though the prairie grasses around the extant foundations are dutifully kept trimmed by park staff hoping to maintain this tenuous hold on the past.

It's a place where history and archaeology collide. The former provides the link between then and now and the latter offers the method to organize and reconstruct time. Fort Union was a veritable city during the latter third of the nineteenth century. Thousands of people passed through on their way to destinations further west. The ruts of their journeys are still visible. Hundreds more were soldiers stationed there, doing their time on the frontier, holding the door to settlement open.

All these people left traces of themselves, of their lives, in and around the fort. Nails, cans, horseshoes. Glass, wagon wheels, bullets. After it outlived its usefulness, the last soldiers packed up their few personal possessions and headed out, leaving it to the weather, the terrain, and whomever happened along. The material culture of an era, picked up and studied by later wanderers and then professional truth seekers hoping to paint a picture with the mundane remnants of an earlier century.

It's in these pictures, whether actual or metaphorical, that we look for clues to past human behaviors—reasons for living, reasons for leaving. It's a human need, I suspect, to construct maps based on the past. Maybe we're hoping that we'll do things differently during our present and the vestiges of our existences won't be left to topple in a high wind or crumble to an overgrown foundation. I think it has to do with being remembered. I visited Fort Union in 1999 and I couldn't help but wonder as I studied those wagon tracks etched into the landscape: what happened to all those people? Where did they go? Did they try to plant roots in the unrelenting prairie soil? What did they leave behind?

I have several old photographs that I keep in my file cabinet. I labeled the manila envelope that holds them "future projects." That was about four years ago and still the envelope waits for me to get around to that future, to follow up on a promise. The photos are all black-and-white, various sizes, and they all hold images of women standing outside farmhouses, near small town dwellings, or on the shore of a prairie that stretches way beyond the paper borders.

I've studied the photos and I've been able to assign an era to some. Others have a faint year written on the back; someone's old-style looping cursive. Some

of them were taken in the late nineteenth century. Others in the early to mid-twentieth. I found these photographs while prowling western antique stores, looking for history in bits of material culture. I've seen hundreds of such photos, crammed into boxes labeled "$1.00 each." So I bought somebody else's memories, someone else's family mementos. How did they get there? How could a relative allow a visual record of their past to gather dust and sunlight in a shop? Did generations simply end or disappear, leaving their accumulations to people like me willing to drop a buck for other people's pictures?

I also have a collection of photos that I myself have snapped on my western wanderings. These depict the other half of the puzzle in my manila envelope—abandoned buildings, minus any people. Sometimes I study both sets of pictures, trying to determine whether any of the structures I've photographed match the houses in the images I've bought. Maybe, I think, I can give the antique store women a context. I can place them somewhere. I can reconstruct a lineage, a before and after. Or maybe I'm just playing God. Besides, the future I've captured in my pictures probably isn't the kind of "after" those women want as remembrances because it speaks of failure, of hope lost, of infertile fields and a hardness bred through hardship.

The West is littered with abandonment. Historian Patricia Nelson Limerick calls the West "a cult of ruins."[3] I am inclined to agree with her assessment of why that might be. Beyond the hundredth meridian—that mystical border that those in the throes of Manifest Destiny crossed to reach the frontier—the West has a different kind of terrain that fell outside Eastern expectations. Arid, often agriculturally unsound, and subject to unexpected climate patterns, this

West had conditions ripe for failure. In addition, the vast space of this region kept settlements in a constant state of vulnerability. If a town couldn't score a railroad connection or a highway, there was no way to make a living, no way to link to other towns. Furthermore, the West's reliance on extractive industries to fuel local economies created boom-and-bust cycles. A town's dependence on often one commodity left its residents vulnerable to the whims of the market and to the depletion of the resource. And finally, many western towns were founded in an era of accelerated development; speculators planned townsites often without consideration for later viability.[4]

Specifically, the 2000 census discovered that the Great Plains (and the lesser plains in association) have continued to lose population in rural counties. In addition to an aging demographic and declining fertility rates, the Plains don't speak of homestead success. Fitch's photographs are evidence of this. This isn't anything new; Plains population peaked in 1920. Since then, they've lost over half a million people—a third of their population and hardly anybody on the outside noticed. From four homesteading families per square mile, to miles and miles of marginal farmland owned by one family or one company, the Plains are no longer the promised land of a westering population.[5] They were settled less securely than governments or societies admit and for over a hundred years, there's been a slow depopulation. Since European settlement and the inadequacies of the 1880s homestead policy, the region has suffered repeated large economic and social collapses. The 1930s brought drought and depression, and the 1980s and 1990s brought agricultural busts on the Plains.[6]

Consequently, towns failed. Homesteads failed. The promise of a chunk of one's own land to pass on to children didn't live up to expectations. So people left. They walked away from the myth of success on the packed plains earth, leaving their frustrations and grief in the rooms of their former homes, along with all manner of personal belongings. Why, then, are we surprised?

From my own explorations of abandoned homesites on Colorado, Kansas, and New Mexico flatlands, I've come across all kinds of things that didn't make the final journey with their previous owners. I recall a furnished living room in a weather-beaten early twentieth-century house in Colorado's San Luis Valley. The interior walls had layers of tattered, peeling newspapers pasted to them, with dates ranging from 1912 to 1945. A large stuffed chair squatted in a corner opposite the entrance, filling hanging out like entrails, pockmarked from rodent incursions. Stiff, dirt-encrusted piles of clothing lay scattered on the floor, though I don't know whether they belonged to the house's original residents or to later passersby. Outside, the remains of an animal pen leaned crazily into the wind, boards sticking out at odd angles.

The place smelled musty, almost like mildew, though all its doors and windowpanes were missing. I remember as I stood reading what I could of the newspapers on the walls that they probably served as insulation against the winter; the boards that constructed that house weren't sealed and didn't meet tightly. Maybe the inhabitants just got damn sick of freezing in the brutal Valley winters so they fled to a warmer climate.

Still, I wondered at the things they left. And I decided that what they didn't take spoke of a feverish desire to be gone, to just be done with the place and its

overwhelming demands. And, like so many westering folks before them, they struck out to start over once again, leaving the evidence of failure behind. Who wants to be reminded of that? I guess I can't blame them their leavings. I try to imagine what these places looked like minutes after abandonment, days after, months after, and I think maybe they're like living things that die, whose bodies go through a cycle of decay before final reclamation, subject to forces of nature and its denizens. Did those who left mourn? Hold a memorial service? Or did they set their lips tight and not look back?

Steve Fitch, I think, operates on a similar wavelength to mine. He, too, seeks out this peculiar western litter, poking through the past, asking questions of it that aren't obviously answered. And he presents his queries to us here in images of interiors, some cluttered with the evidence of what seems to be a hasty departure, others only minimally decorated but no less haunting in the little that does remain. Dishes on a table. A made bed. Books still adorning school shelves. Small plastic saints on a cracked kitchen counter. I'm particularly struck by two images. In one, we see a bed and just above it, hanging on the wall, a photograph of an older couple. Someone's parents? Grandparents? I am uneasy at the thought that this picture was left behind. What were the house's residents running from? Why did they leave this evidence of their existence behind? Did the past accuse them of not trying hard enough to stay? In this instance, maybe people didn't want to be remembered.

The other image depicts the interior of a long unused honky-tonk. I'm fascinated by the beer bottle that still stands at the end of the bar. I grew up in a small western town. I've visited my share of local bars and I can say with

certainty that no one ever leaves an unfinished beer. And if the bottle in Fitch's photograph is empty, why is it there? No bartender would leave an empty prior to closing. These are pragmatic observations; the actual circumstances can probably be easily explained. Maybe someone else like me or Steve was poking around the honky-tonk, found the bottle, and placed it at the end of the bar, caught up in the odd juxtaposition of past and present.

But why do these articles remain entombed in these structures? Many of the places Fitch photographed have remained undisturbed. I can only surmise that maybe those who came later and saw these mausoleums to the departed didn't want the failure to rub off on them. They averted their eyes and passed by, holding their breaths, perhaps. Hoping the ghosts left behind wouldn't see them. Wanting to avoid the evidence of loss and heartache that Steve Fitch has recorded. His work here is a rare glimpse of western history. His photographs may make you uncomfortable. They may make you sad. But they will invariably make you think about these people who left their homes, their pasts, and the material manifestations of their memories behind. And perhaps, in the frames of Fitch's viewfinder, these people who didn't want to be remembered have found some kind of redemption.

Eveyln A. Schlatter holds a Ph.D. in history from the University of New Mexico. She is an editor in Albuquerque.

Notes

1. Kevin L. Cook, "Railroad Land Grants and the Settling of the West. Http://www.thehistorynet.com/Wild West/articles/2000/ 08002_4text.htm. August, 2000.

2. Alison Clement, "On Being Wrong," *High Country News* 29:15 (August 18, 1997). Archived at http://www.hcn.org/servlets/hcn.Article?article_id=3576.

3. Patricia Nelson Limerick, "Haunted by Rhyolite," in *The Big Empty: Essays on Western Landscapes as Narrative*, ed. Leonard Engel (Albuquerque: University of New Mexico Press, 1994), 28.

4. Ibid., 29.

5. Florence Williams, "Plains Sense: Frank and Deborah Popper's 'Buffalo Commons' is Creeping Toward Reality," *High Country News* 33:1 (15 January 2001). Archived at http://www.hcn.org/servlets/hcn.Article?article_id=10194.

6. Ibid.

Plates

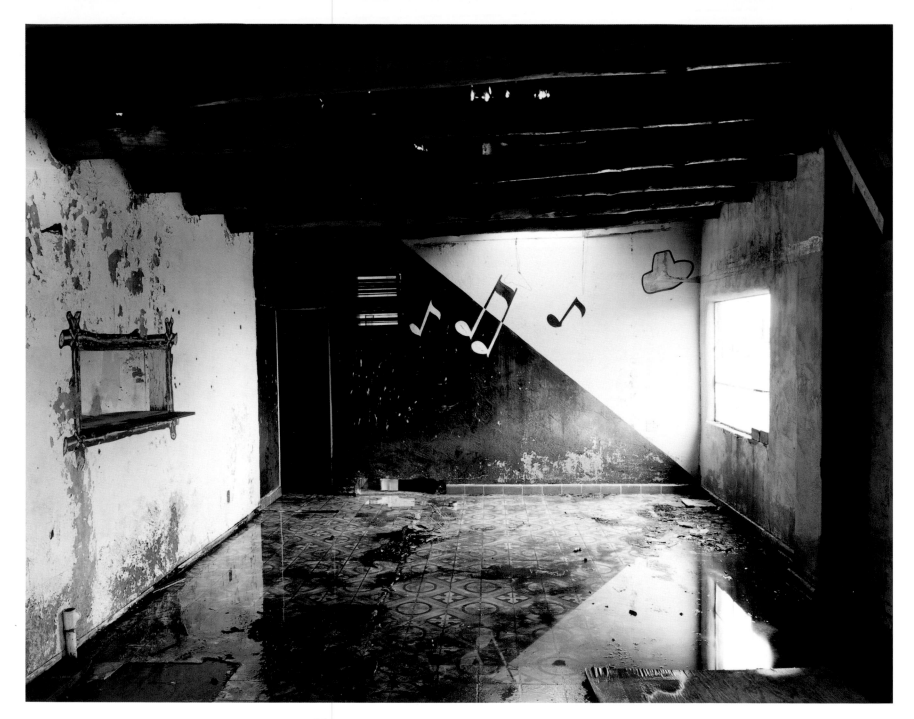

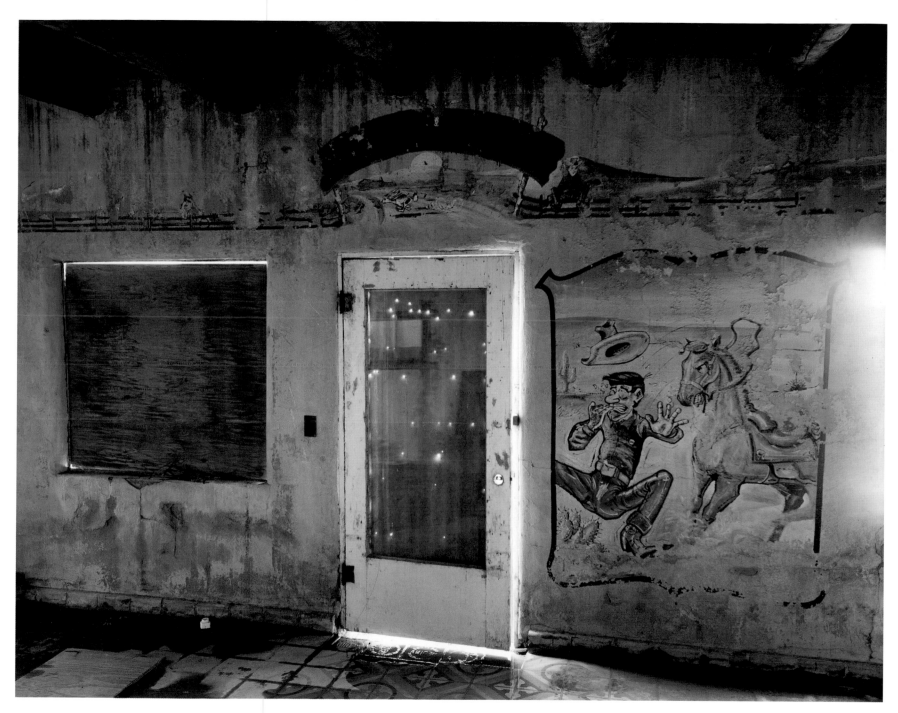

gone

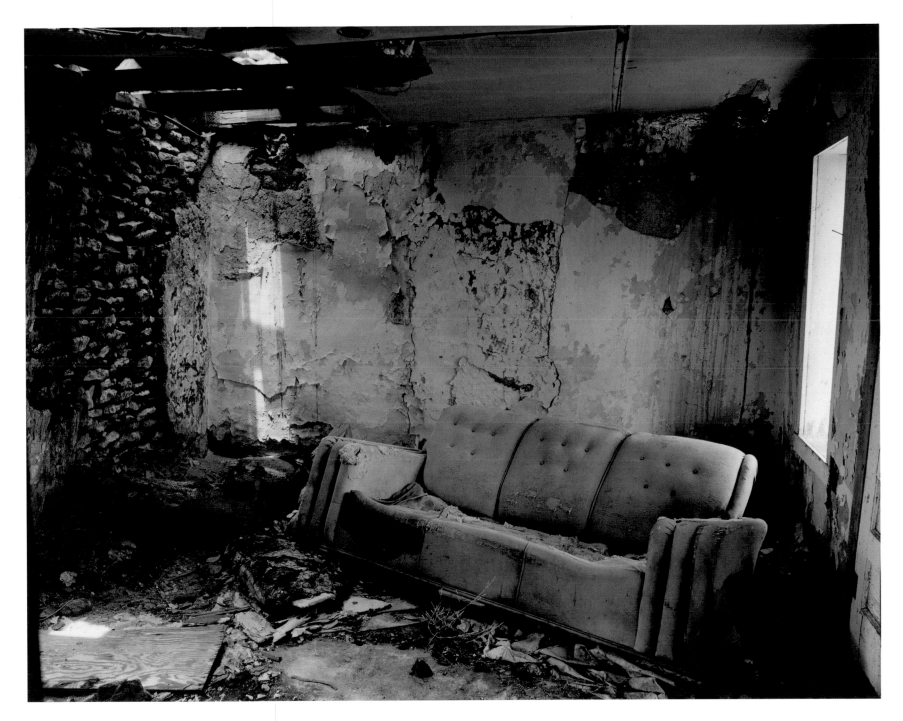

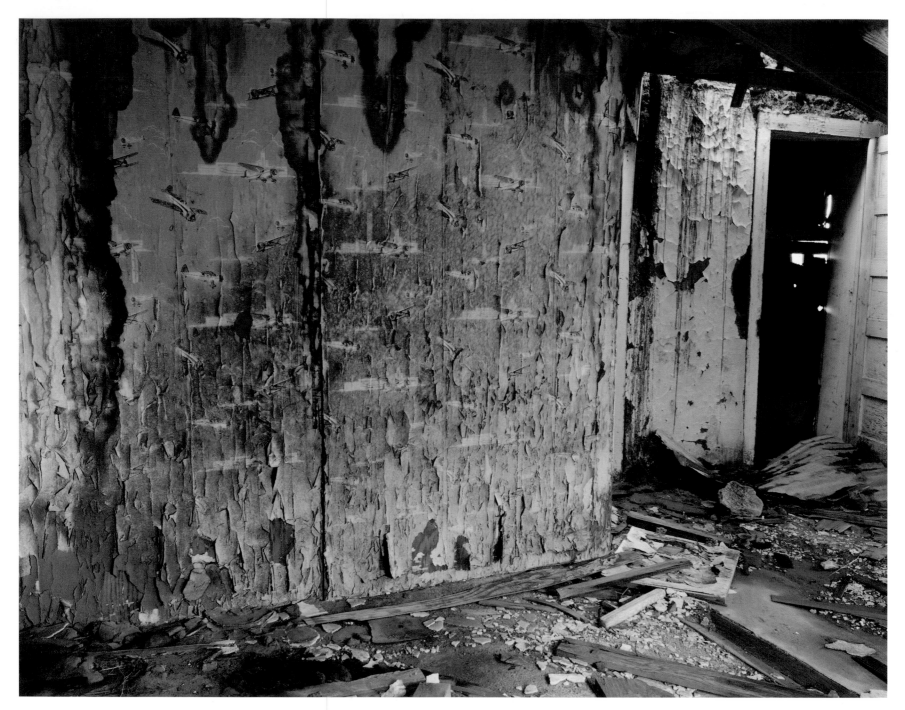

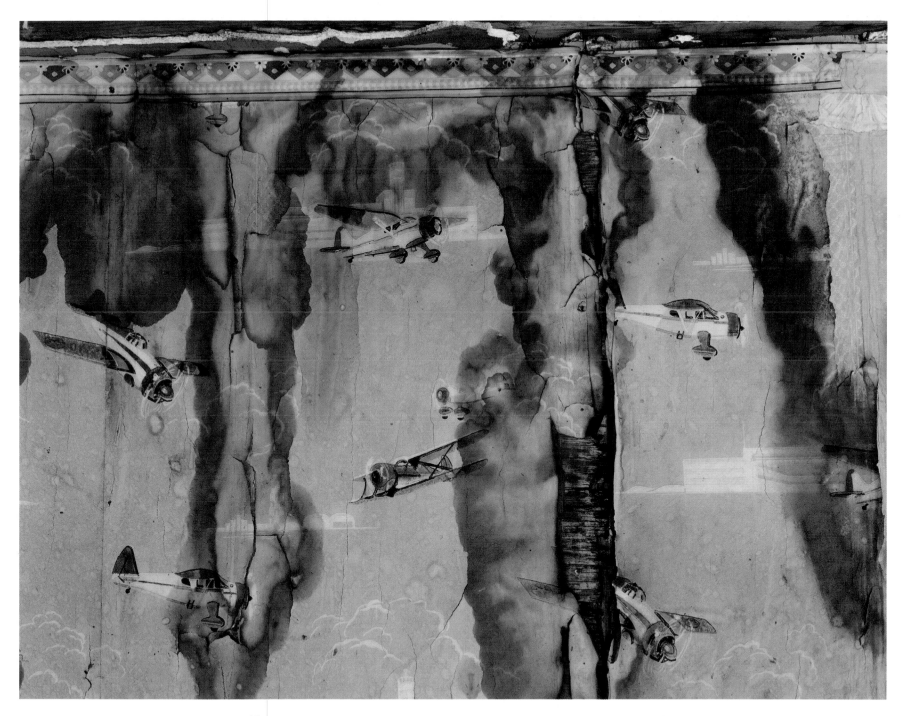

gone

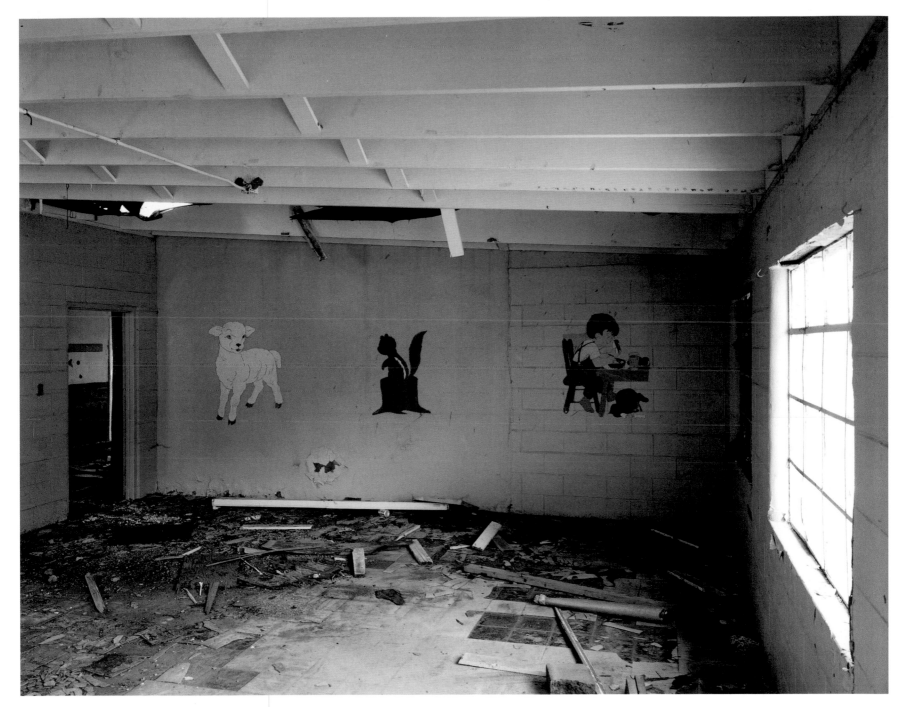

8. *Classroom in a school in Ribera, eastern New Mexico, July 6, 1991.*

gone

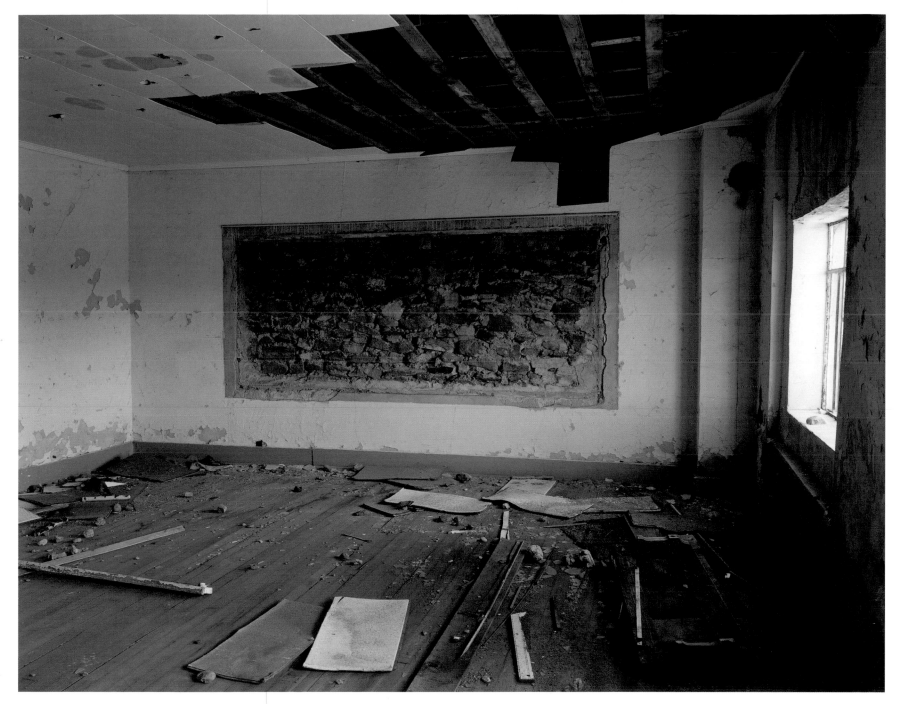

9. *Dance hall in Yeso, eastern New Mexico,*
 July 7, 1991.

gone

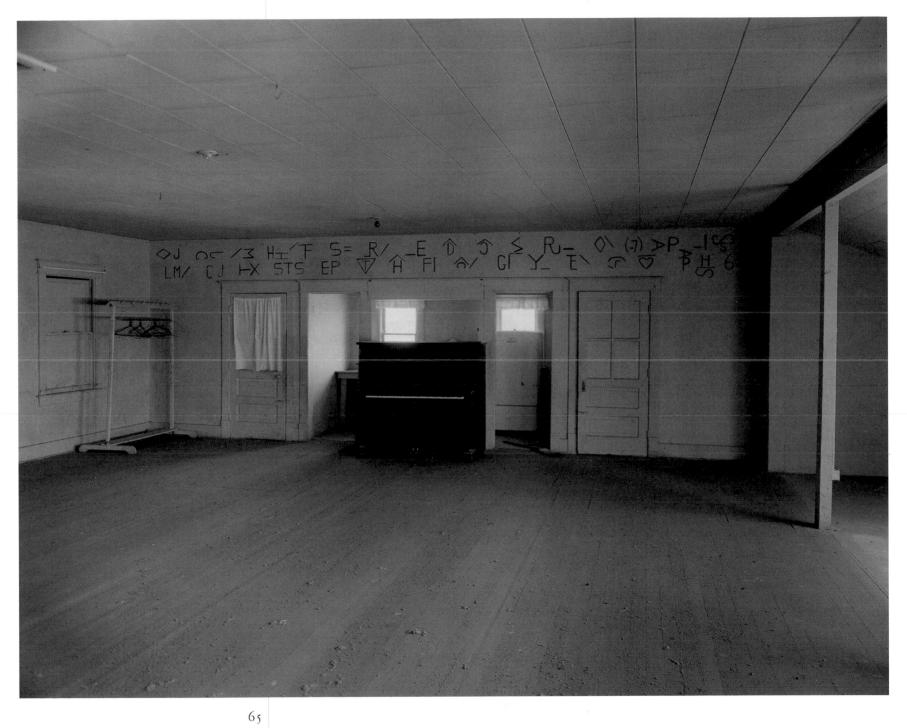

10. *Hallway view through a house in Ocate, eastern New Mexico, August 31, 1991.*

gone

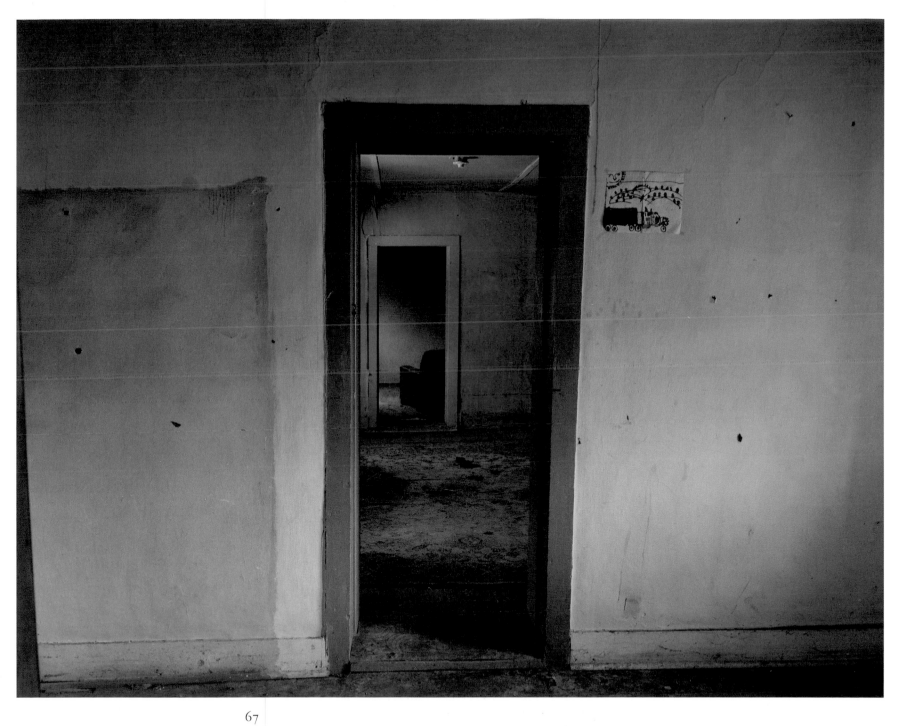

11. *Church near Sapello, eastern New Mexico,*
 August 31, 1991.

gone

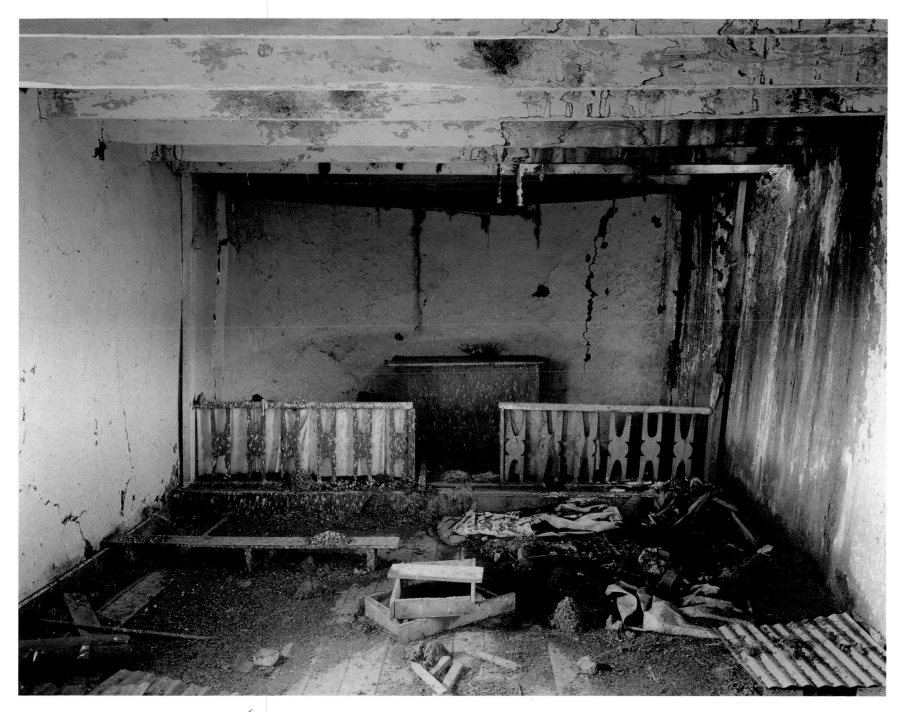

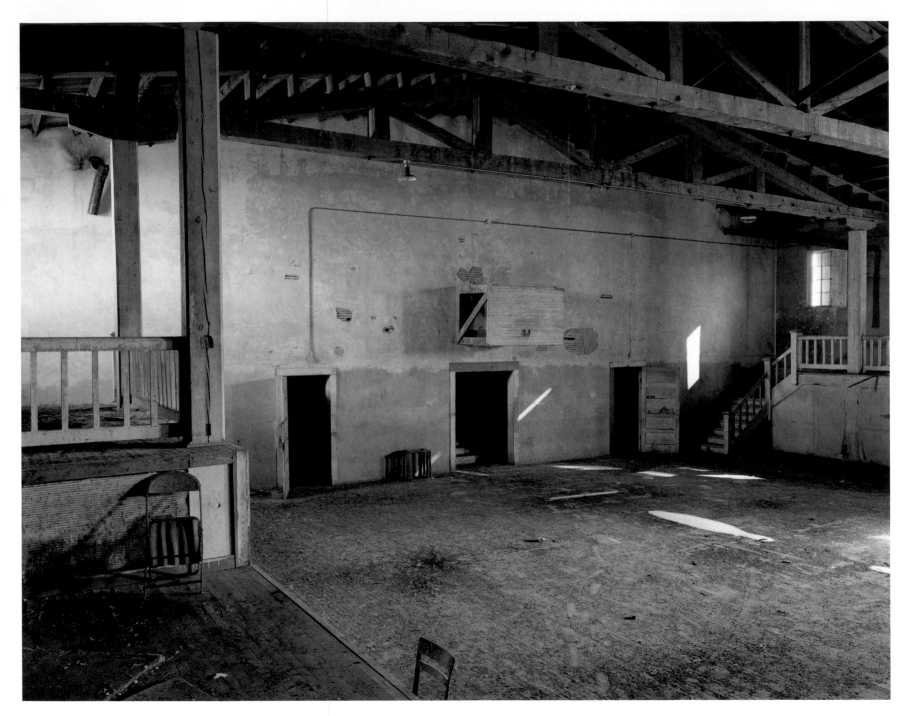

70

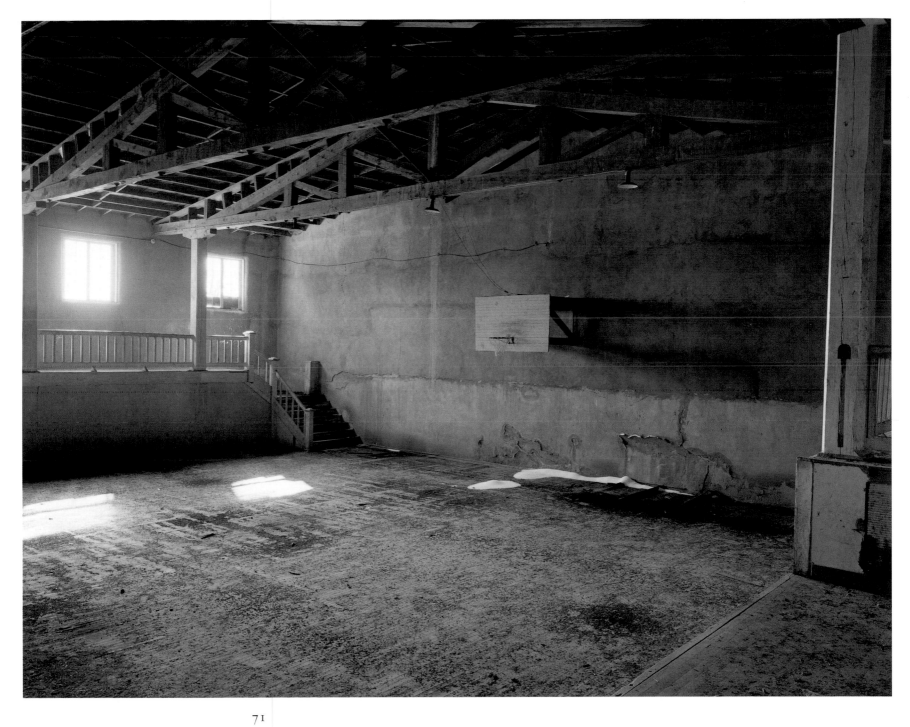

gone

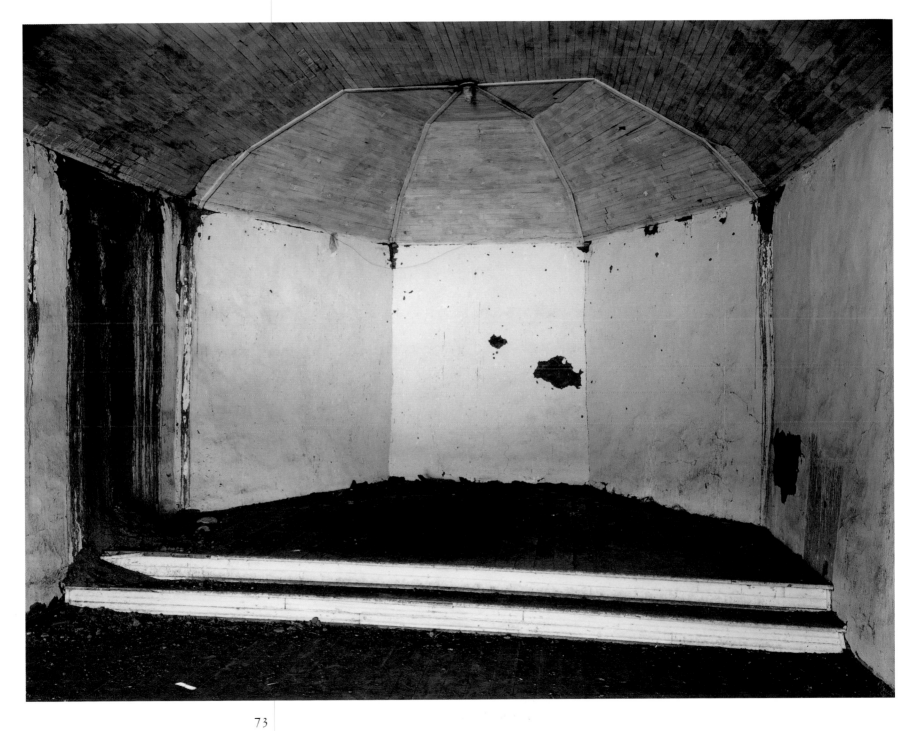

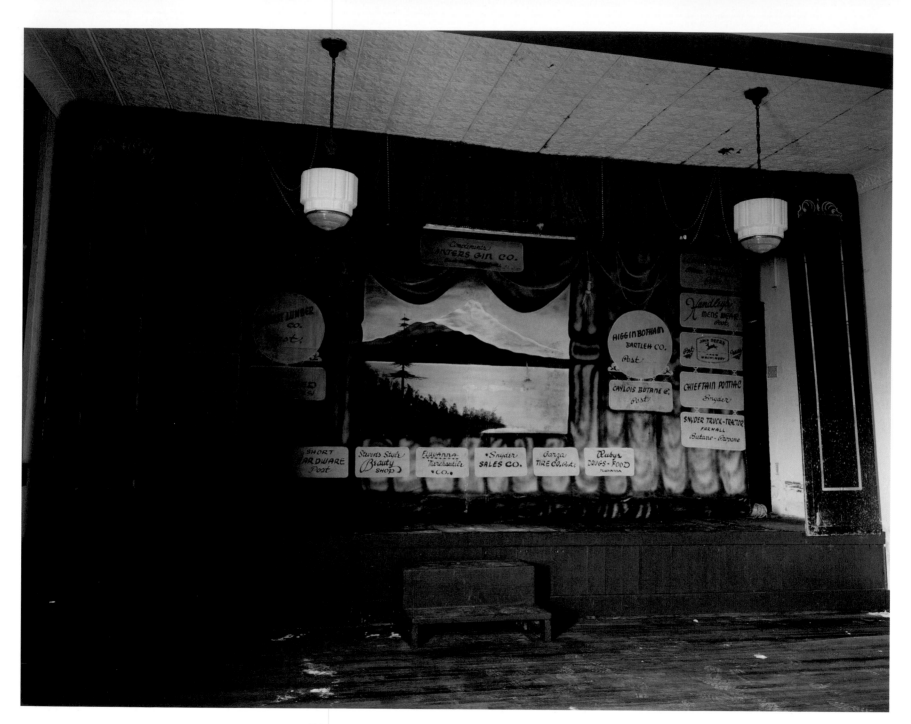

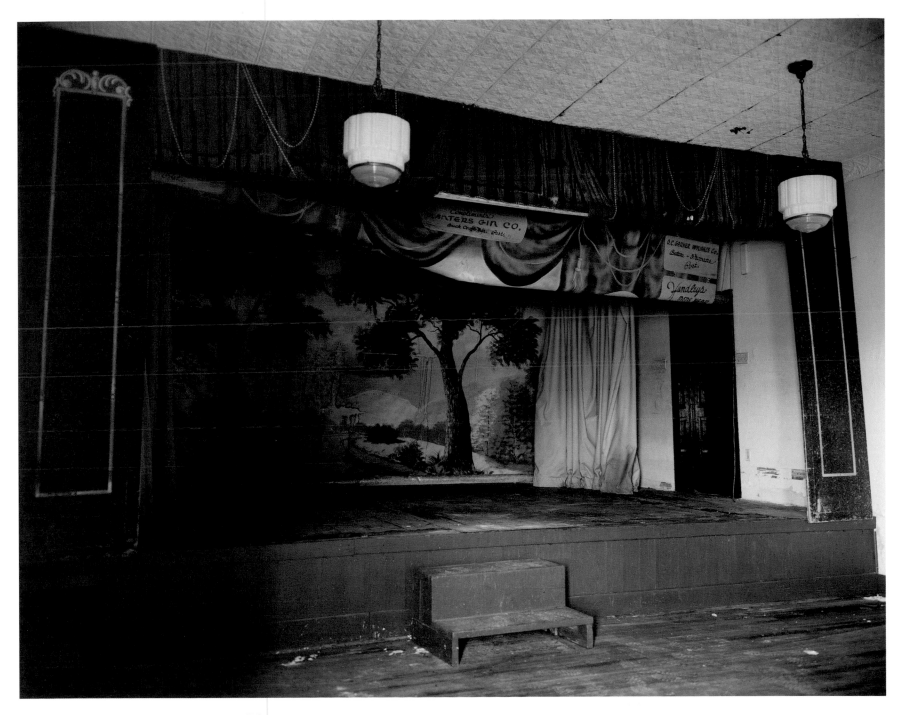

gone

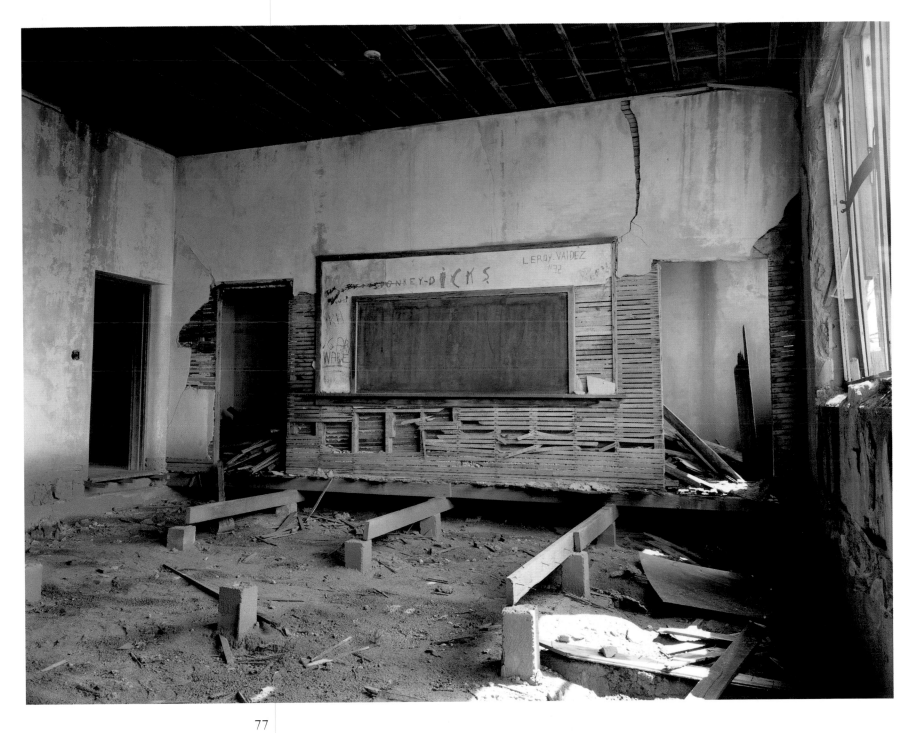

18. Kitchen in a house near Tecolote, eastern New Mexico, May 5, 1992.

gone

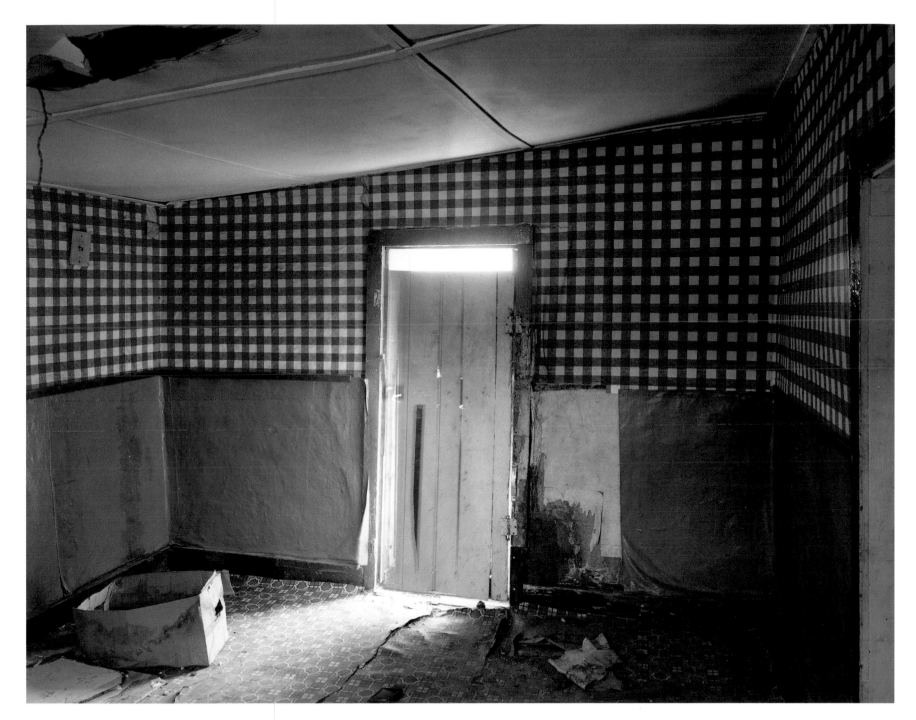

19. Gymnasium in a WPA-built school in
Wheatland, eastern New Mexico, July 17, 1992.

gone

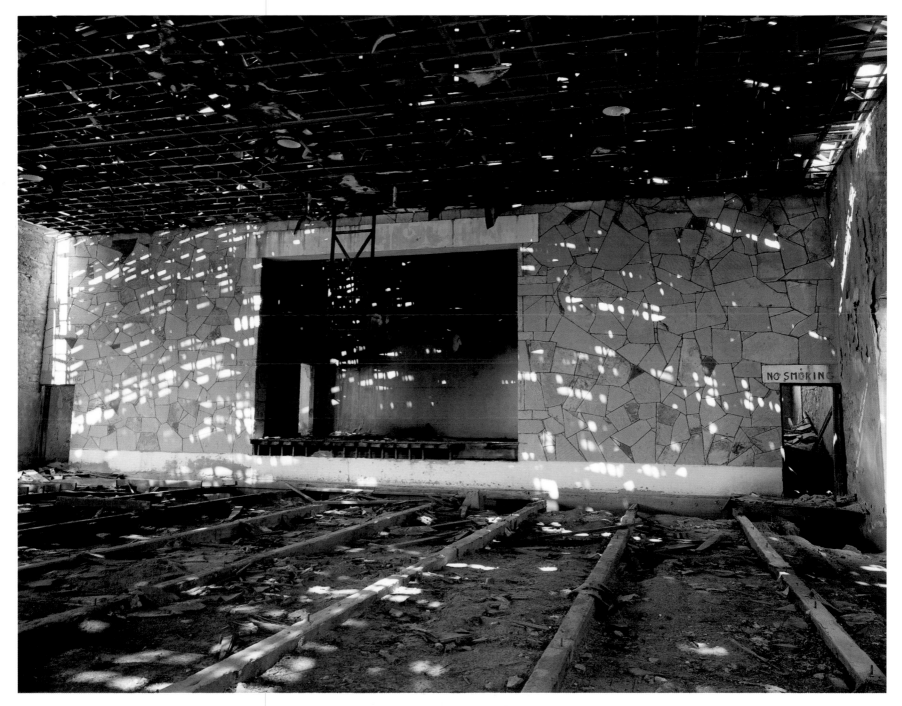

20. *Classroom in a school in Wheatland, eastern
 New Mexico, July 17, 1992.*

gone

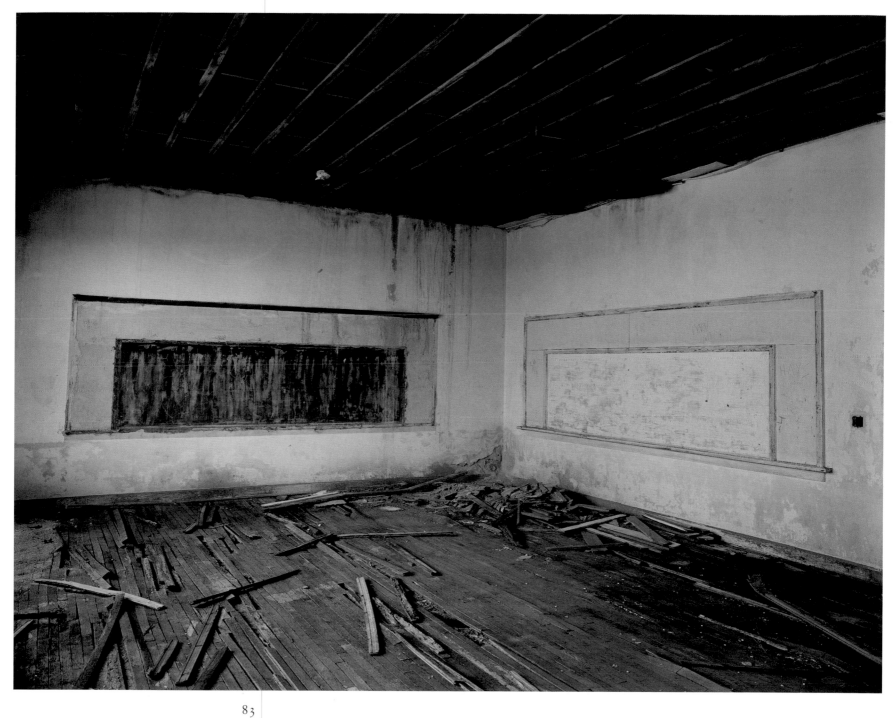

21. *Inside a school in Forrest, eastern New Mexico, July 17, 1992.*

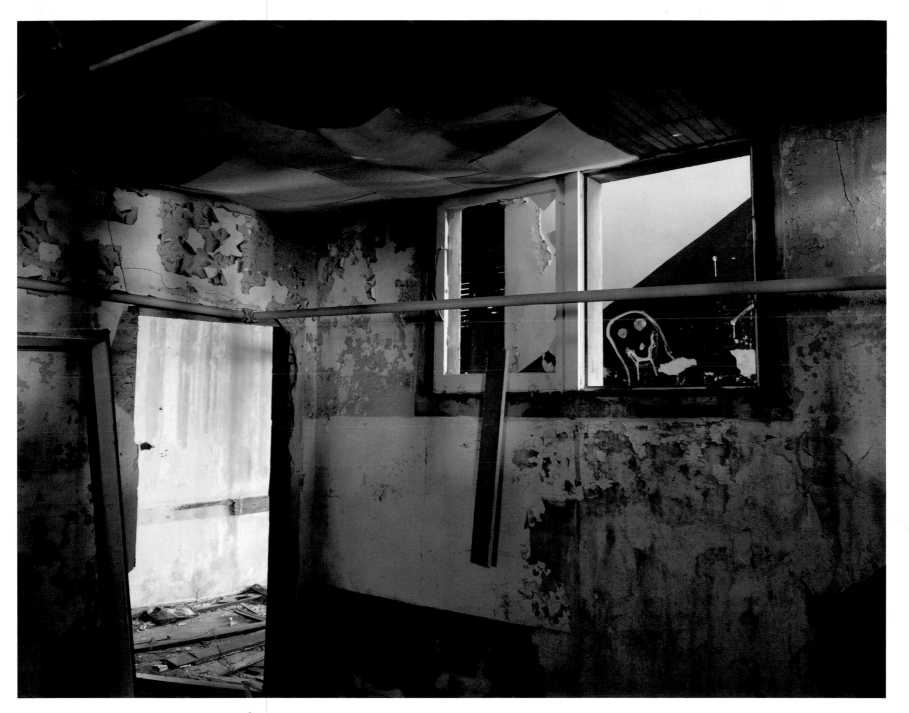

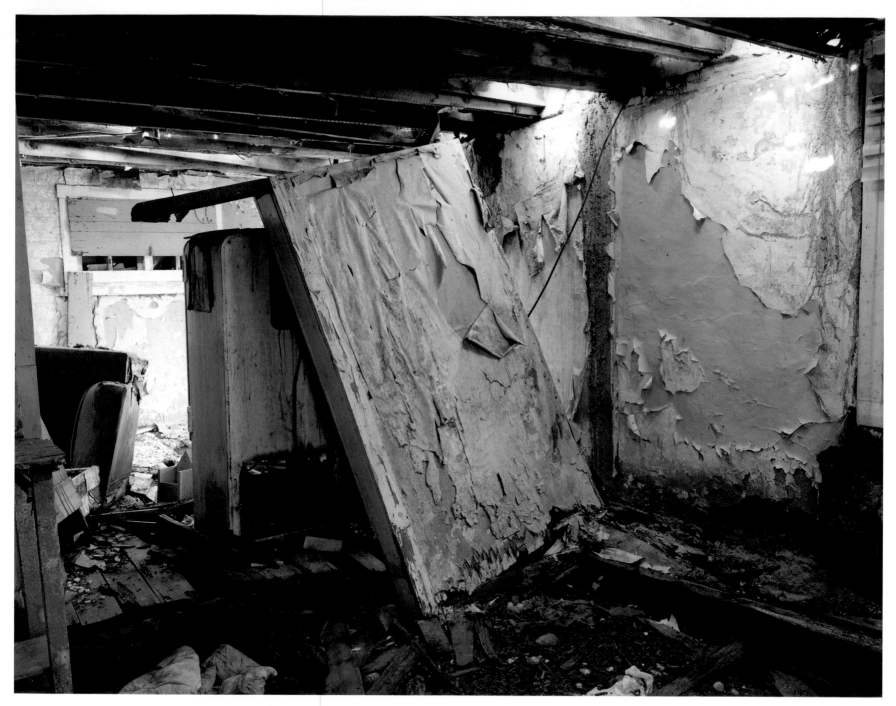

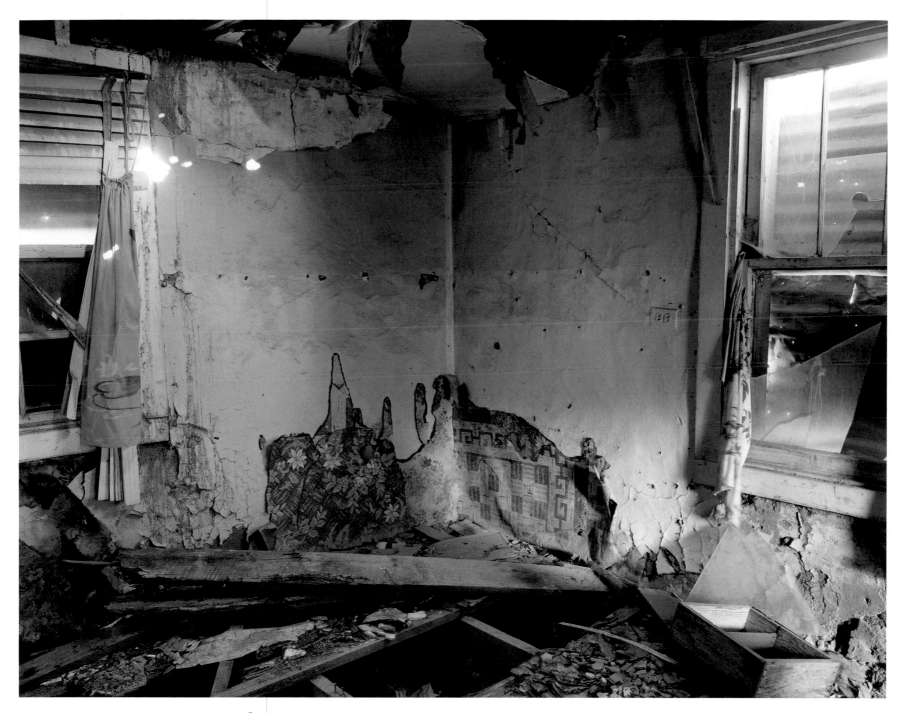

gone

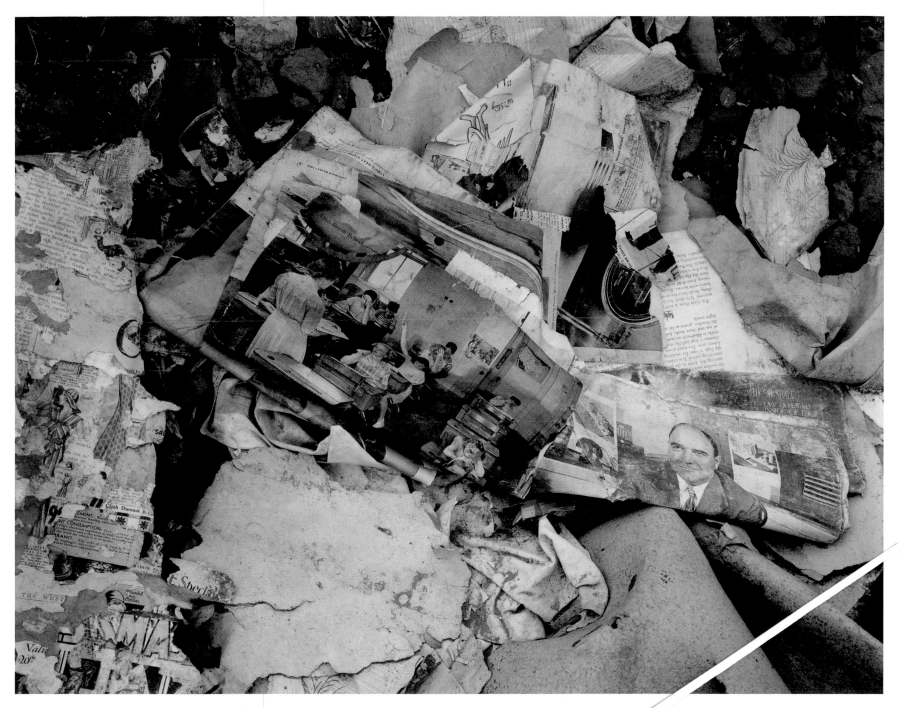

*25. The floor of a school in McAlister, eastern
New Mexico, January 6, 1994.*

gone

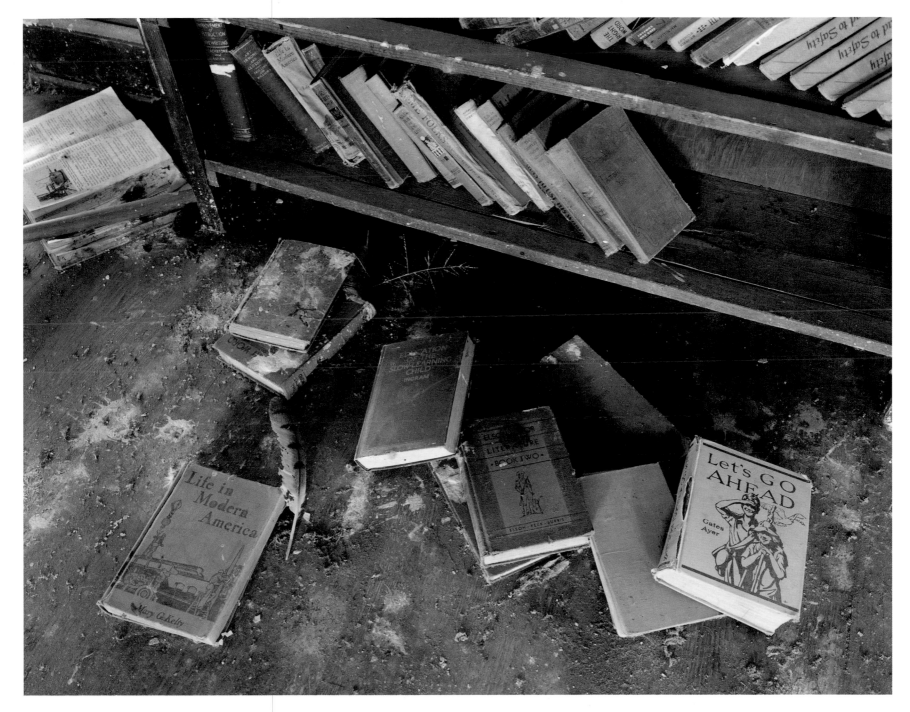

26. *Sunday school in McAlister, eastern New Mexico, January 6, 1994.*

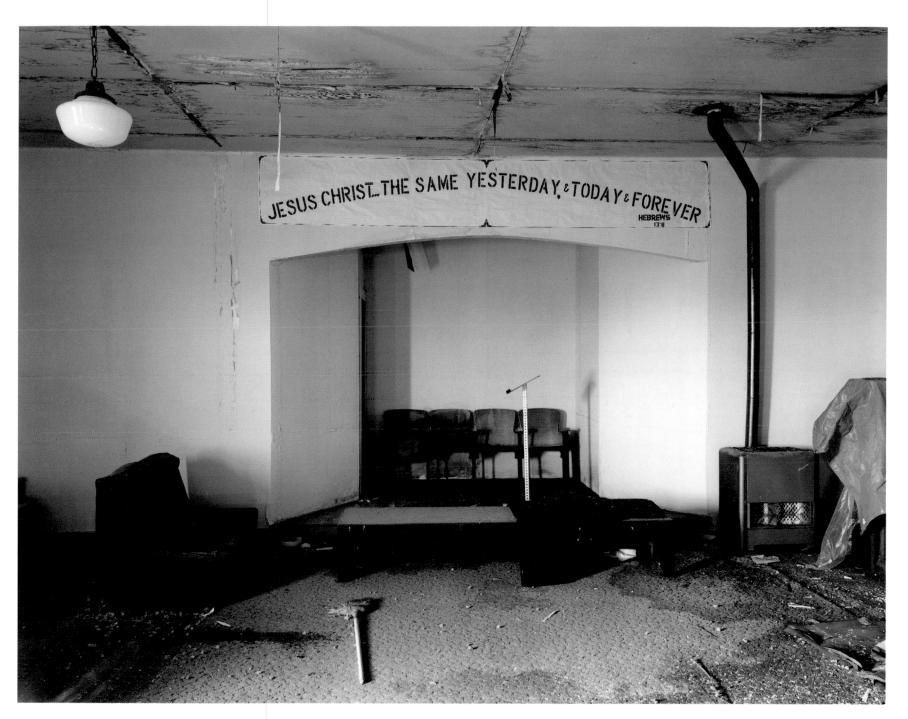

27. *Bathroom in a house in Model, eastern*
 Colorado, February 11, 1994.

gone

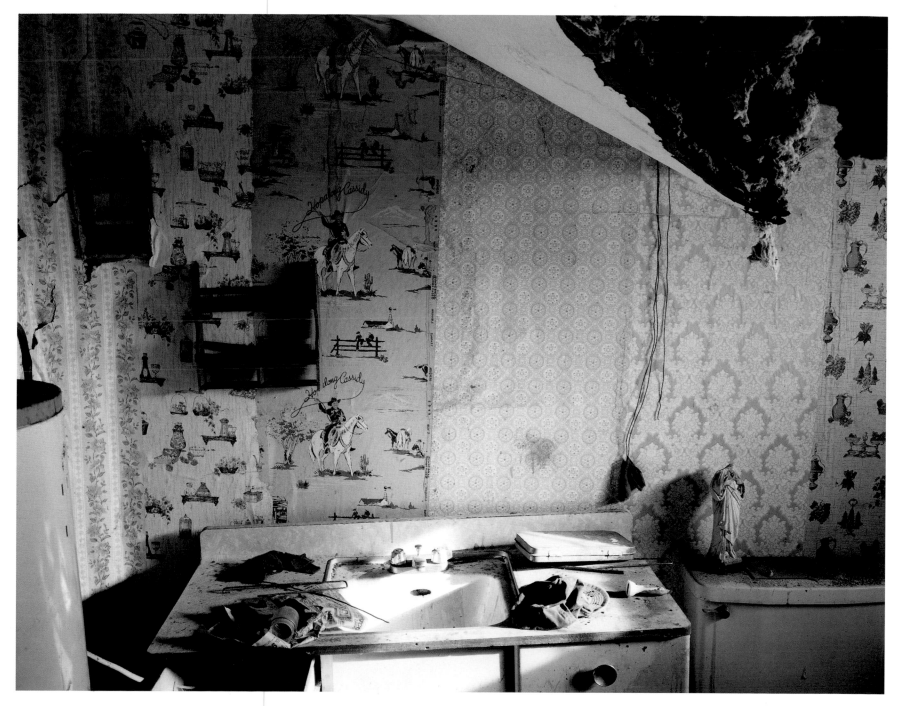

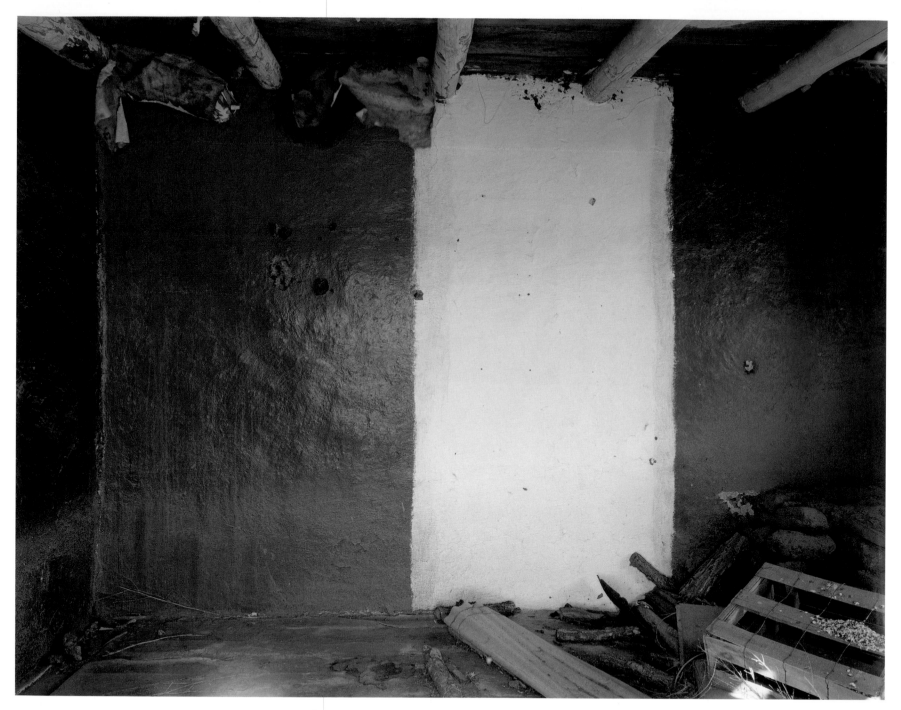

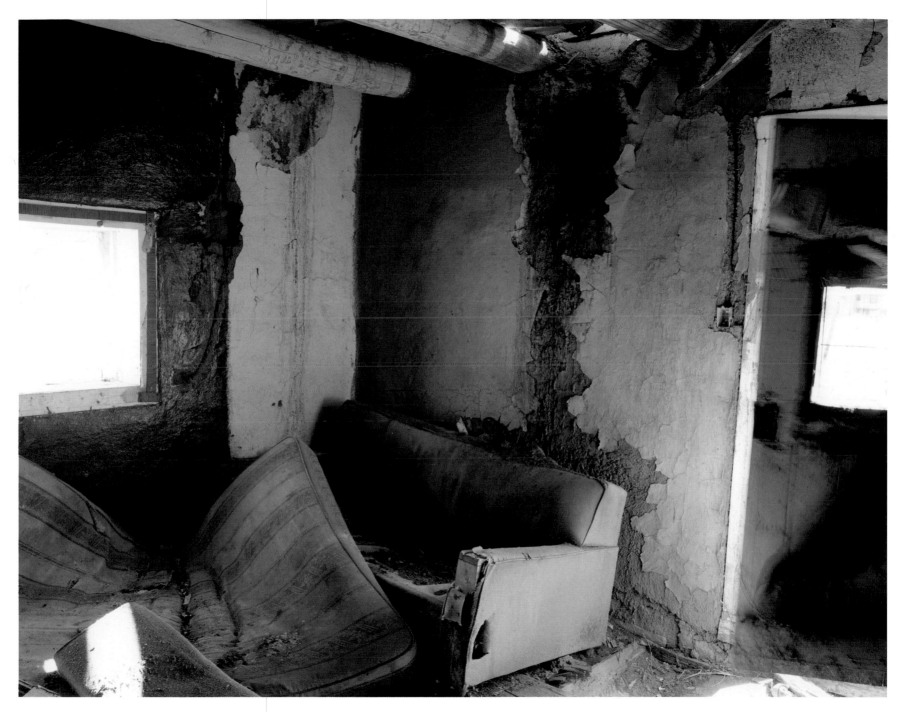

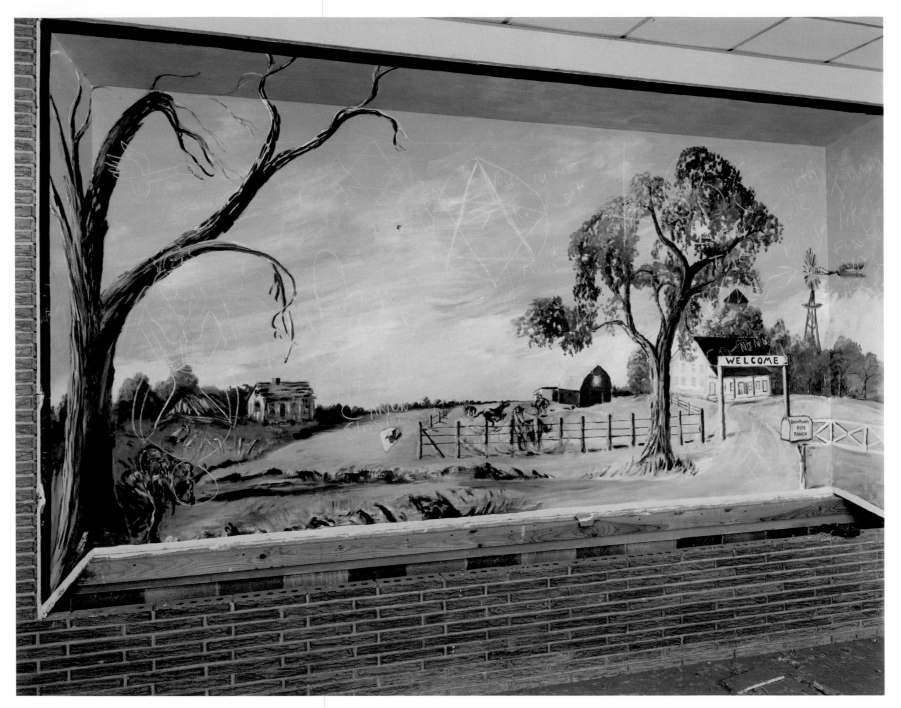

gone

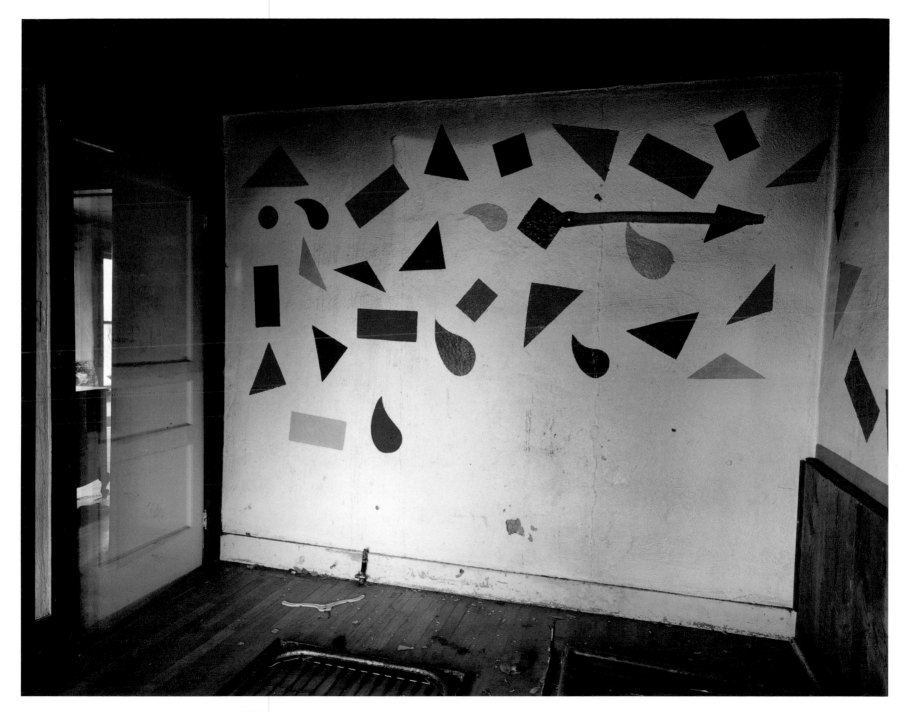

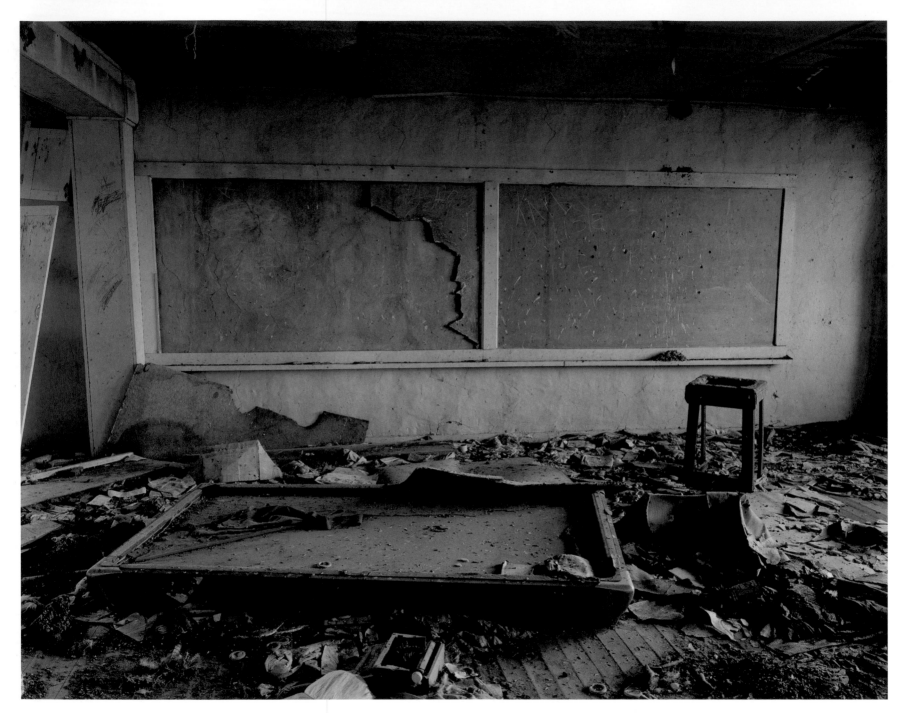

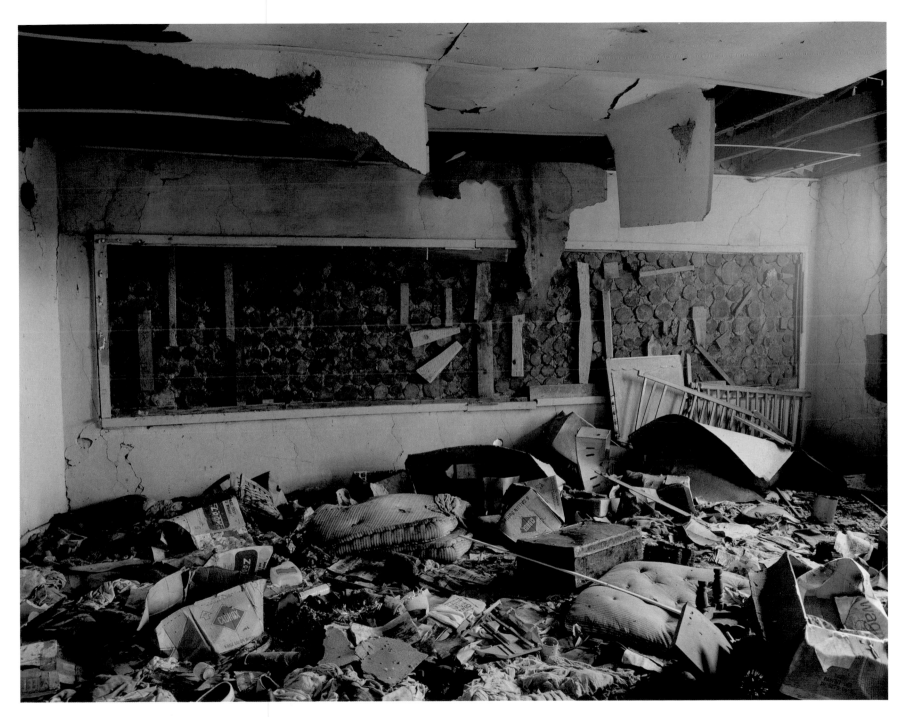

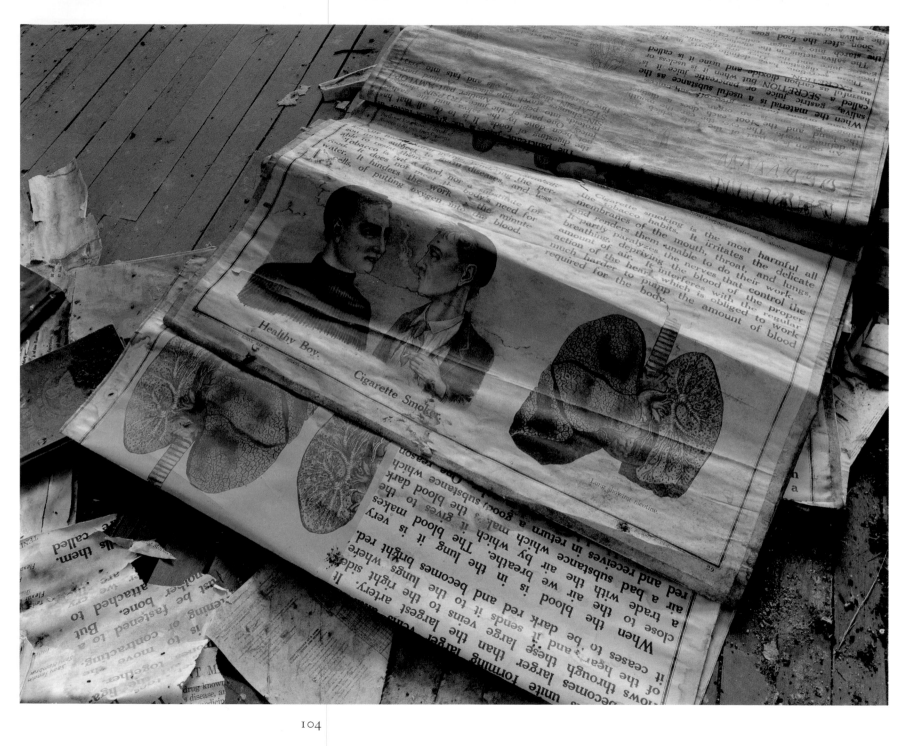

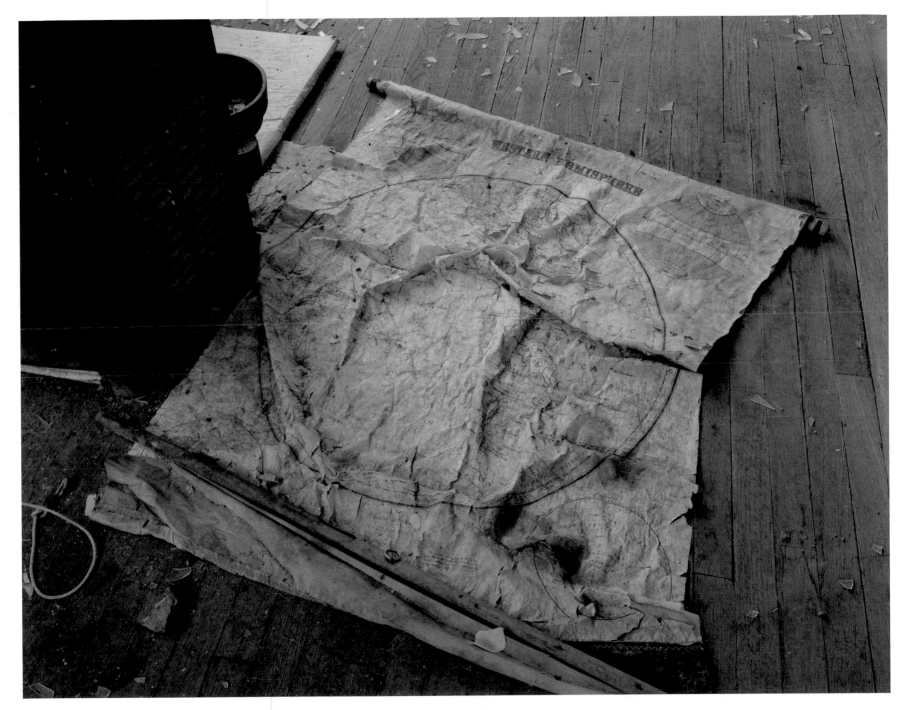

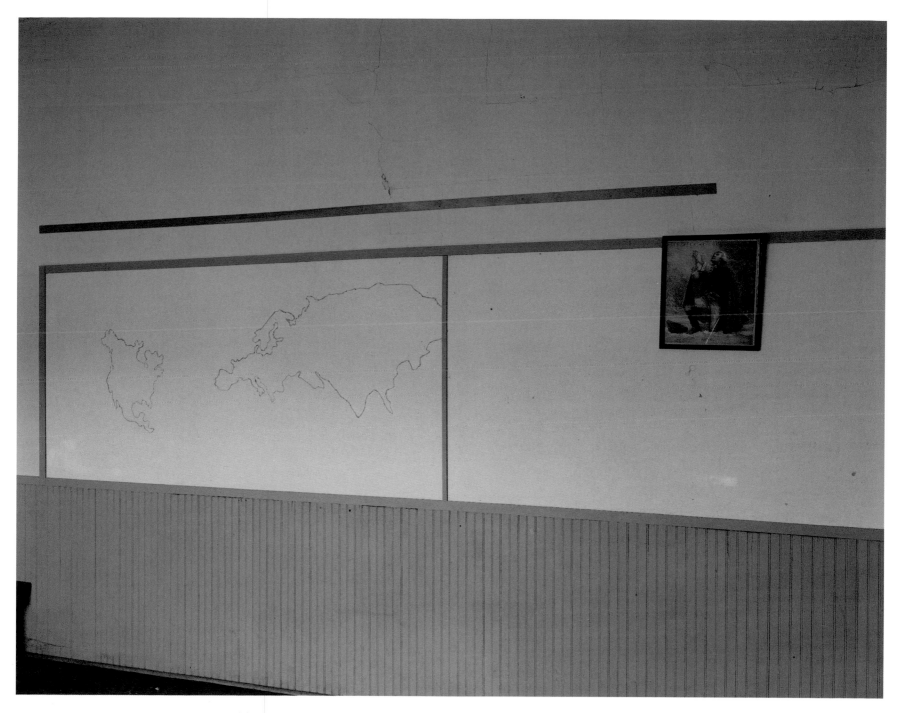

38. *Spaceship wallpaper in a bedroom in Yoder, eastern Wyoming, June 9, 1995.*

gone

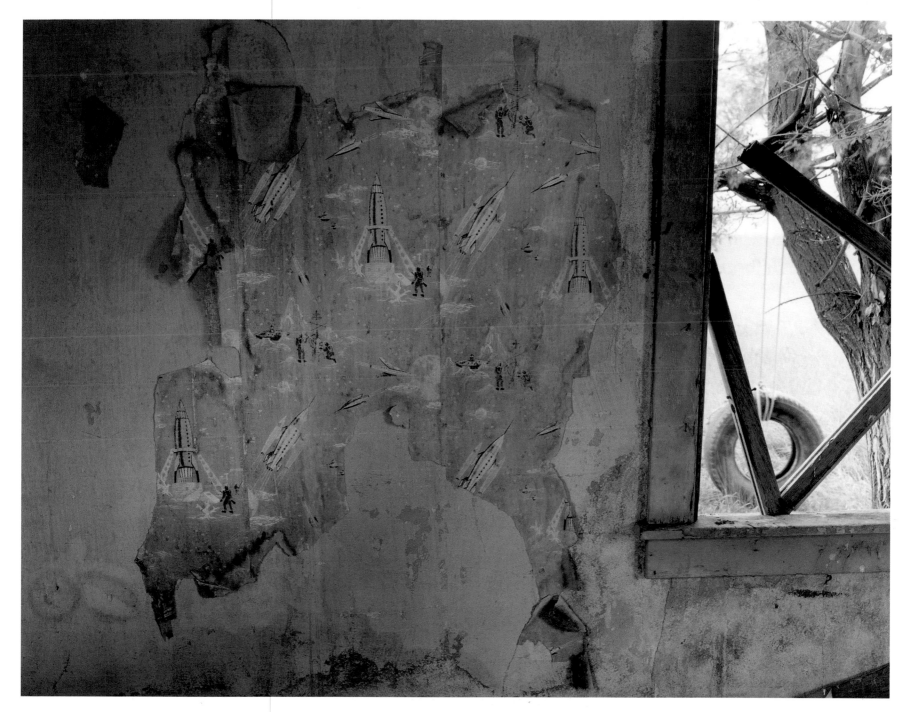

39. Inside a house in Yoder, eastern Wyoming, June 9, 1995.

gone

40. *House made from beer cans in Maxwell,*
eastern New Mexico, June 11, 1995.

gone

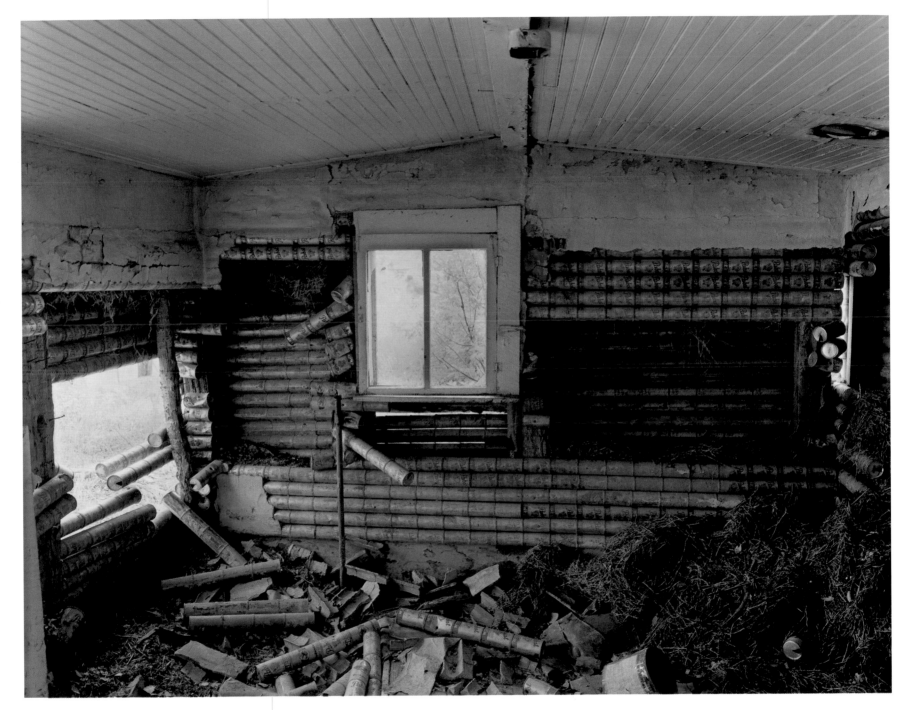

41. *Living room in a house in Aguilar, eastern Colorado, November 3, 1995.*

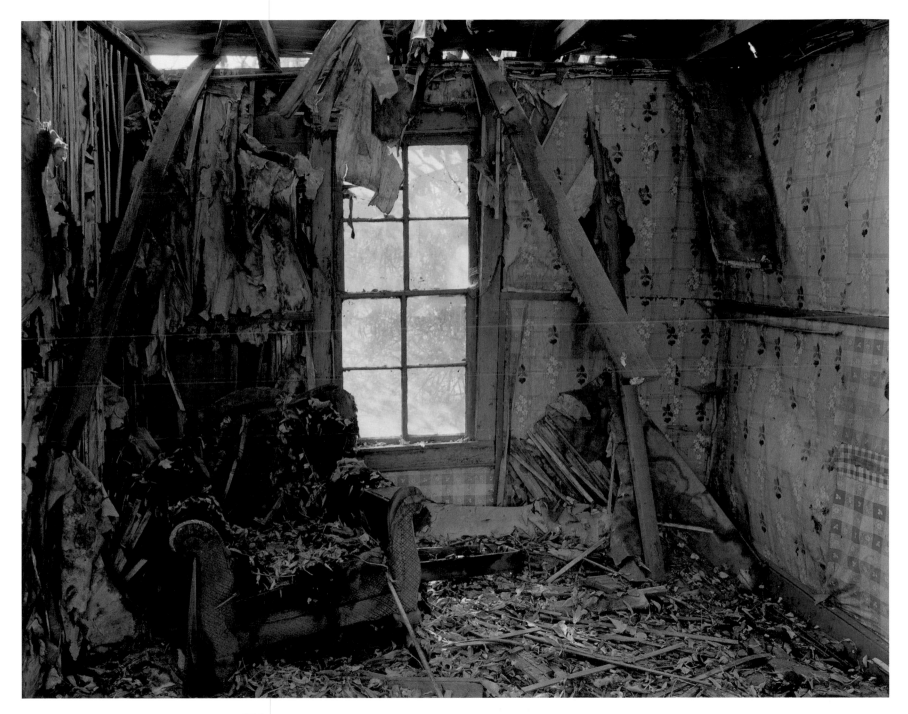

42. *Homemade space shuttle in a house in Modoc,*
 western Kansas, May 15, 1996.

gone

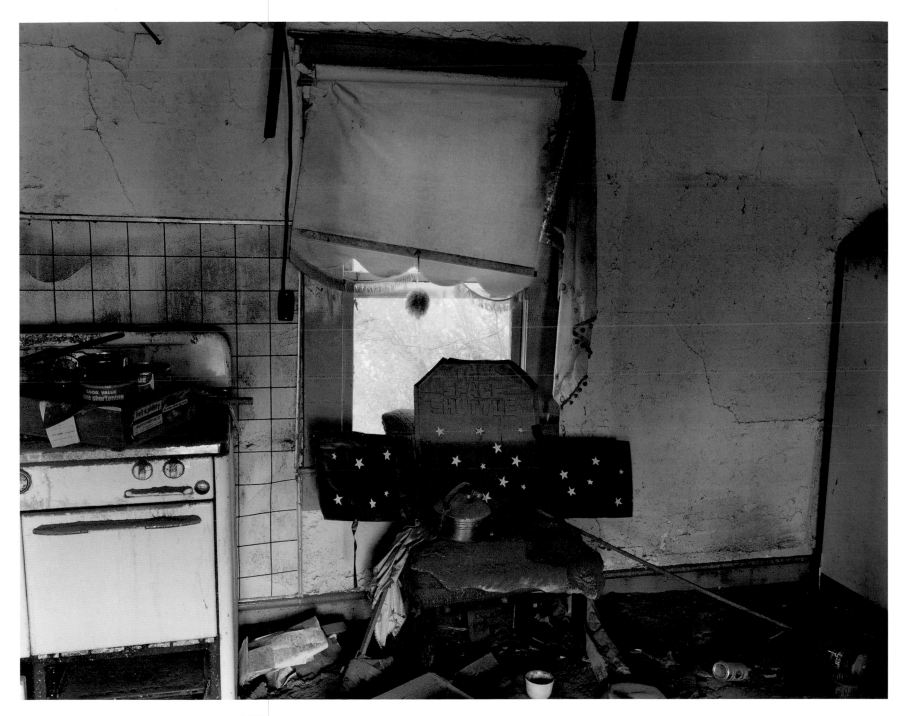

43. *Blackboard with handprints in a classroom in Causey, eastern New Mexico, April 26, 1997.*

gone

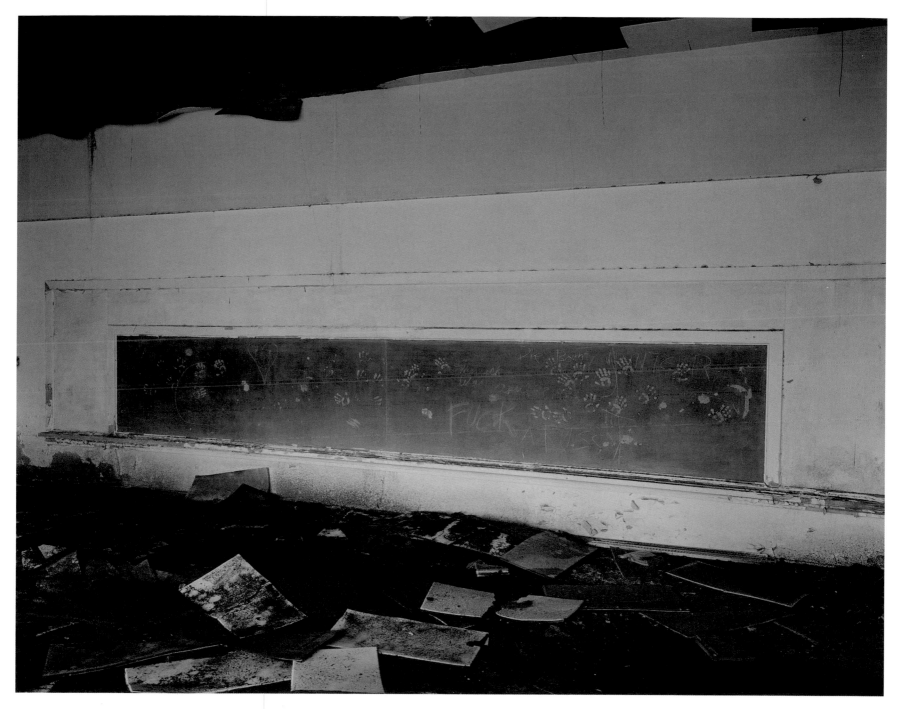

44. *Map of the United States on a classroom floor in Bula, western Texas, April 26, 1997.*

gone

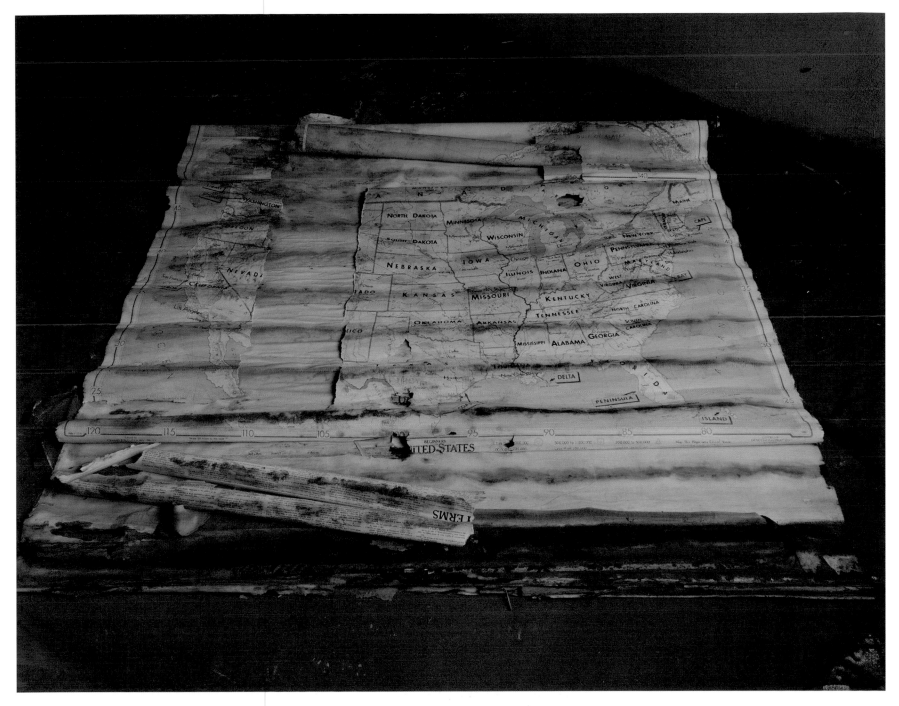

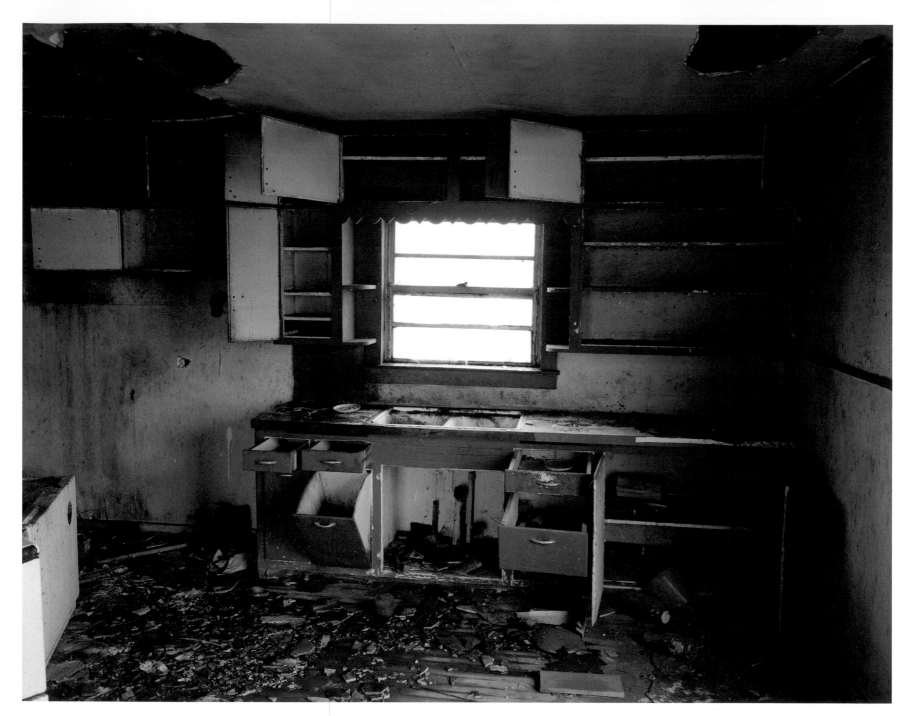

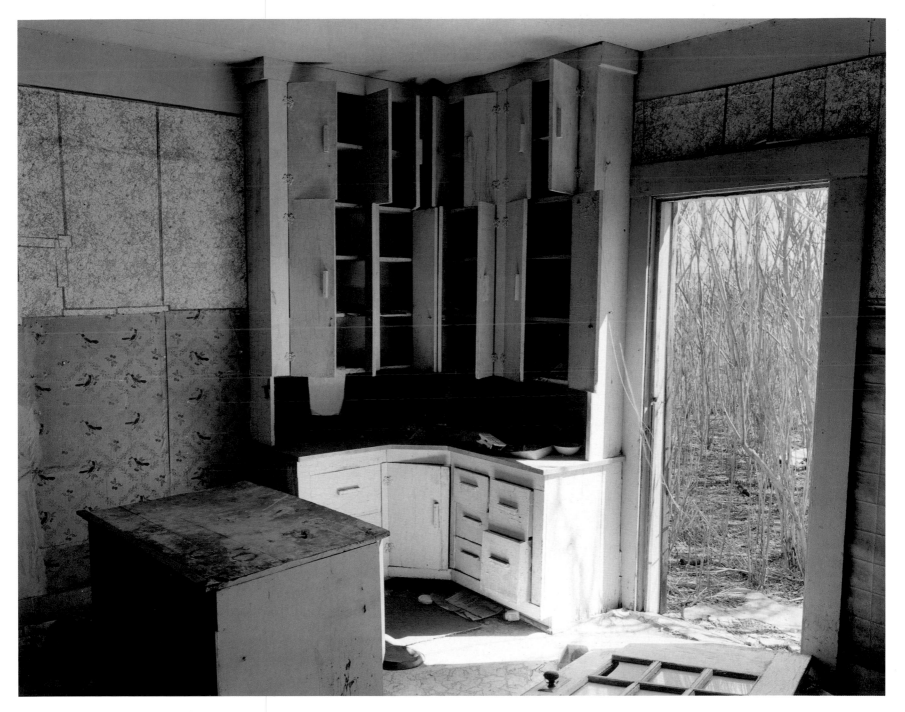

gone

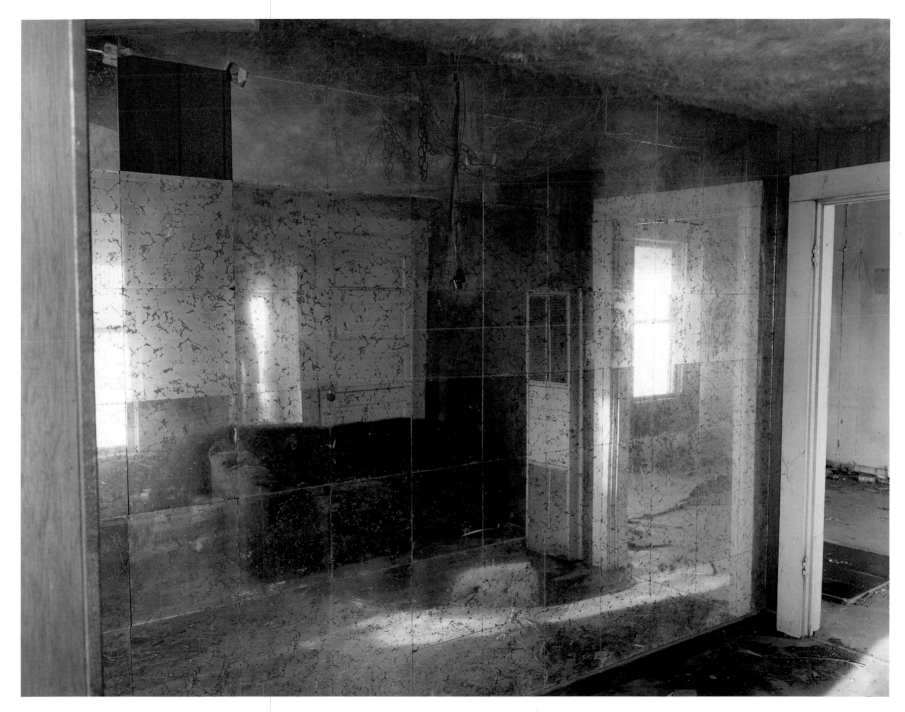

48. *Kitchen in a house in Montoya, eastern New Mexico, March 21, 1998.*

gone

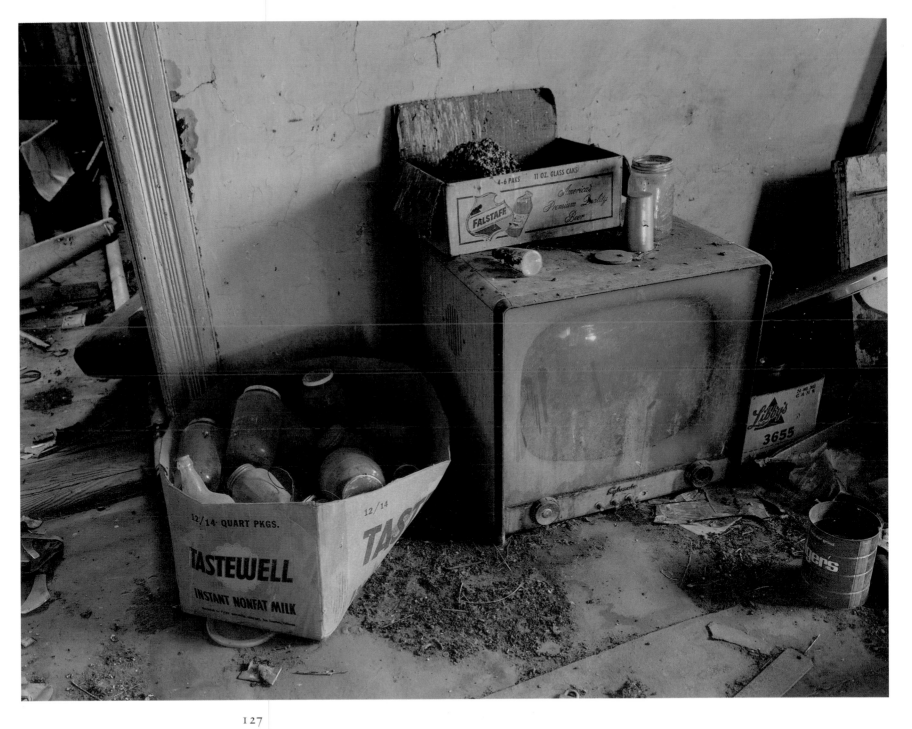

49. *Bar in Gascoyne, western North Dakota, June 19, 1998.*

gone

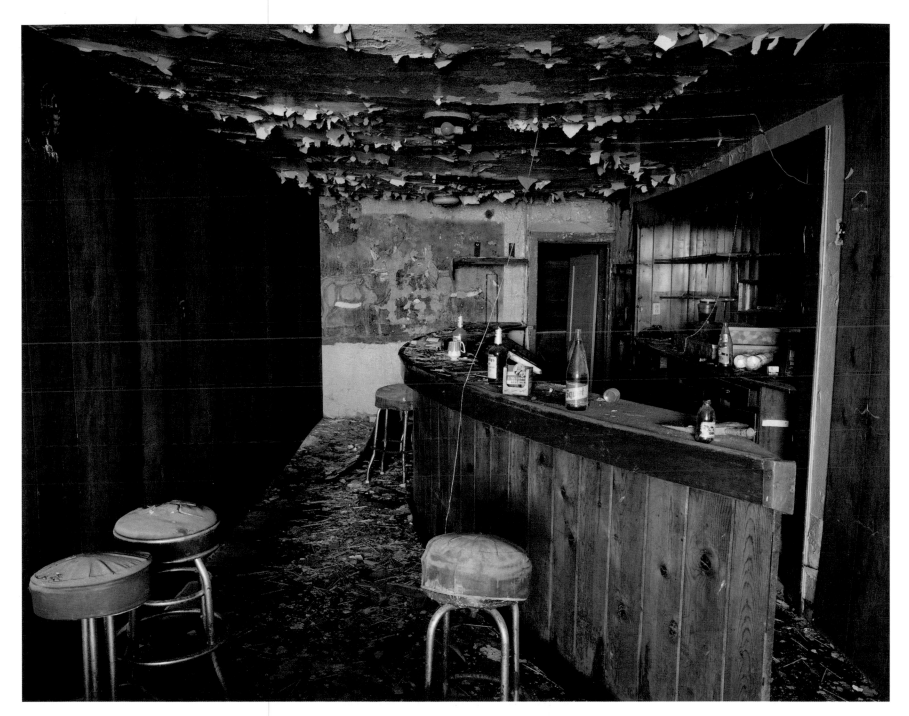

50. A clock that is still plugged in in a kitchen in Ingomar, eastern Montana, June 22, 1998.

gone

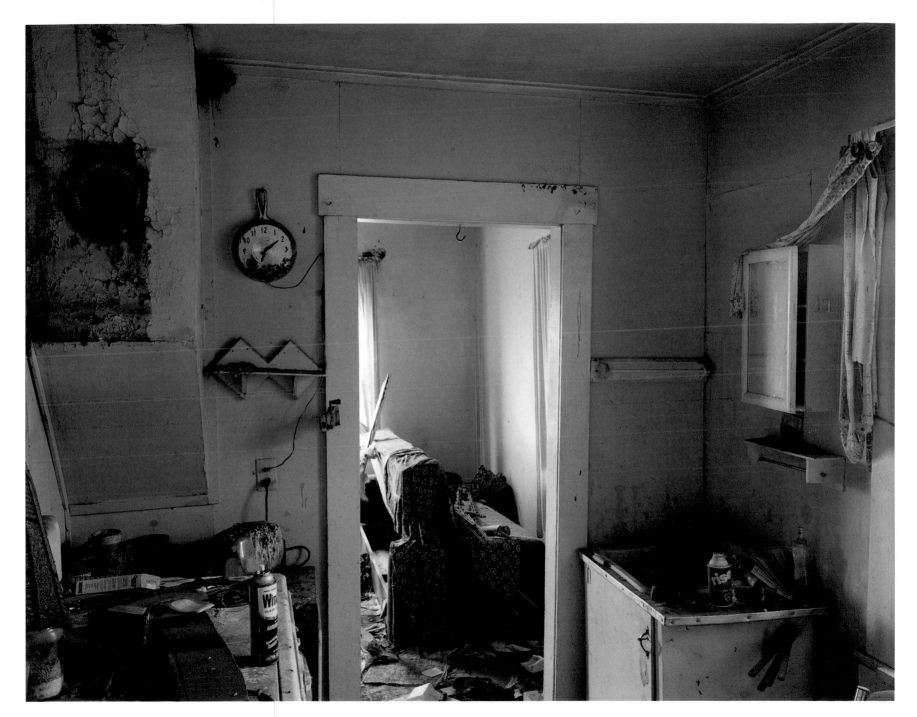

51. *Calendar left on the living room wall in*
 Ingomar, eastern Montana, June 22, 1998.

gone

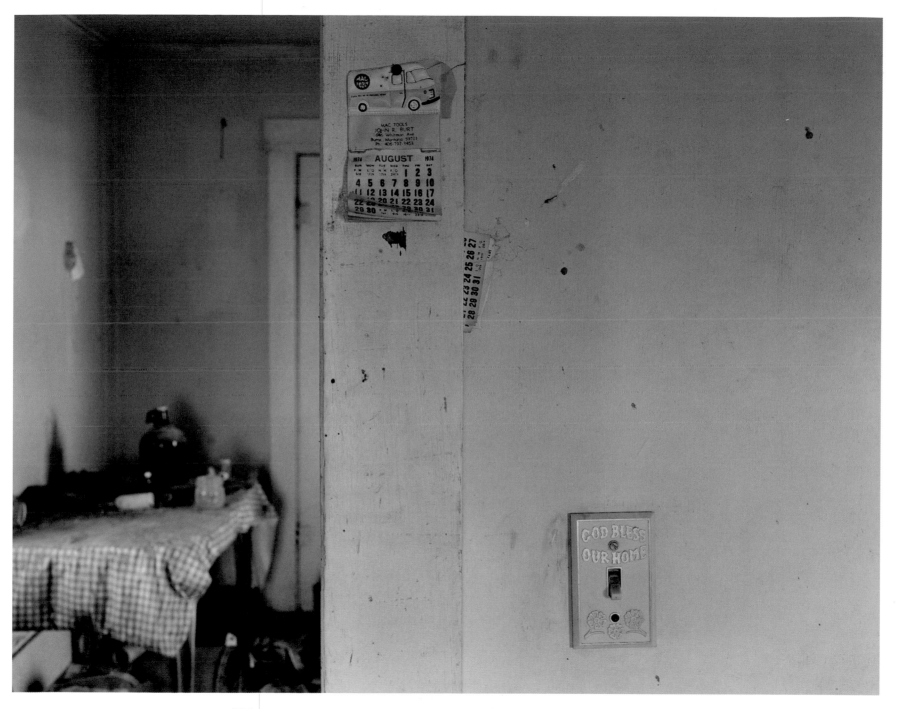

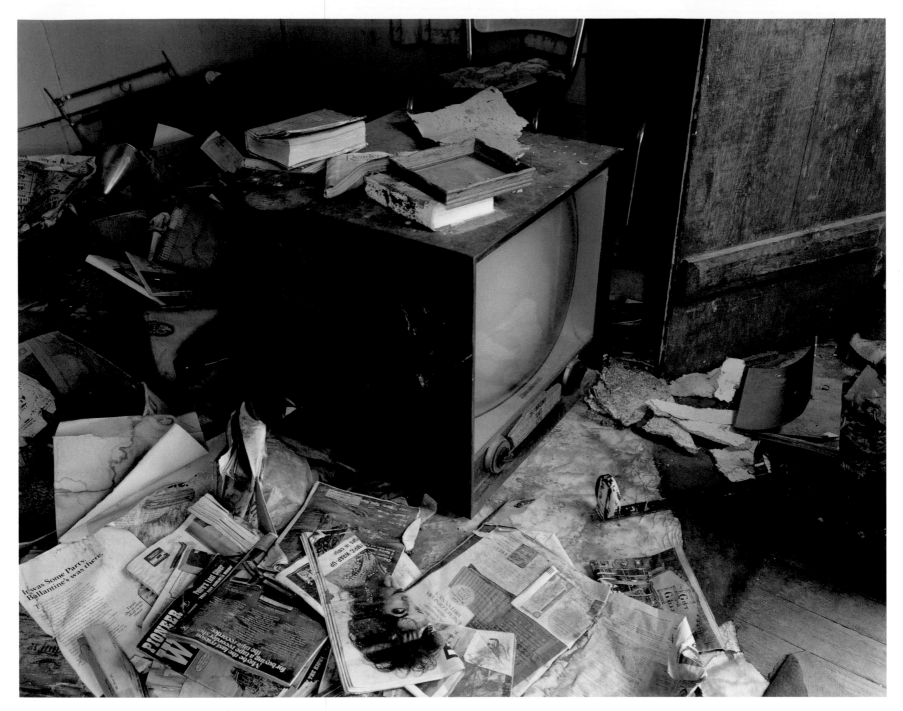

134

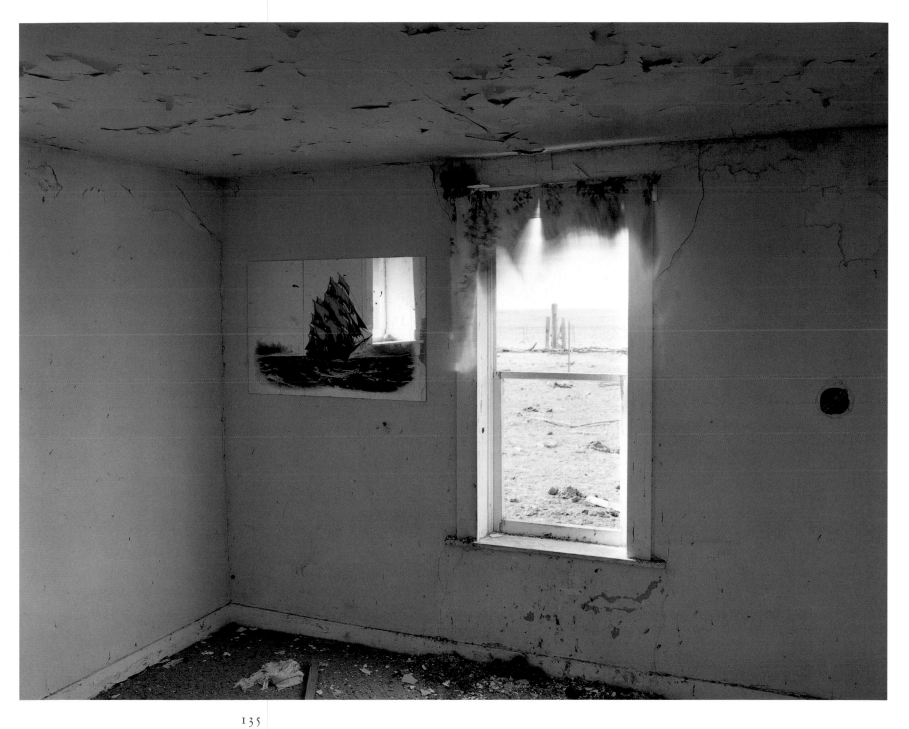

gone

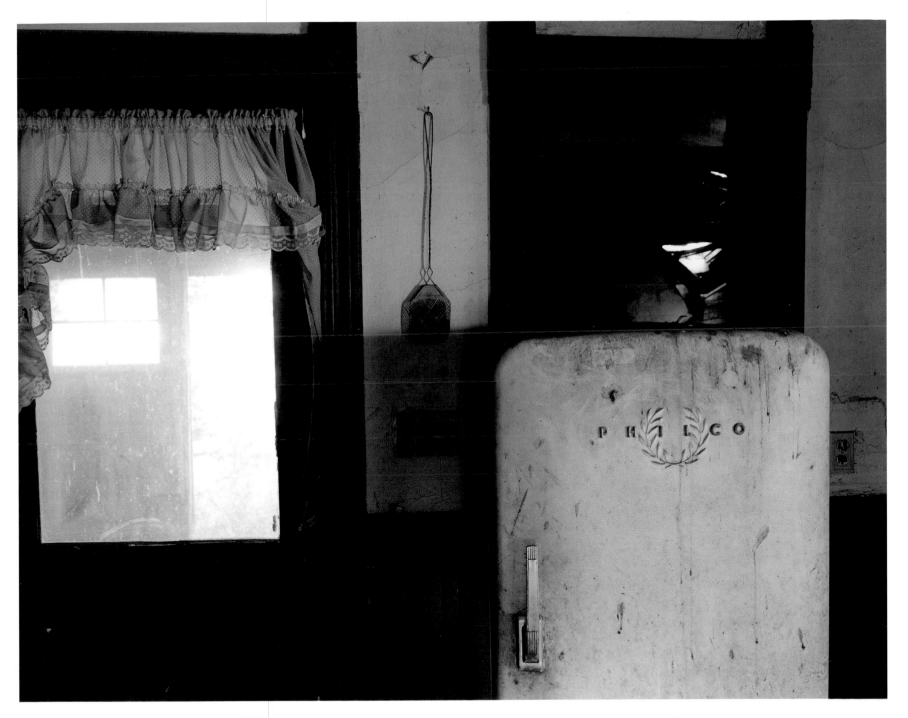

55. *Bedroom floor in a house near Hudson, South Dakota, July 2, 1999.*

gone

56. *Kitchen in a house in Ludlow, eastern*
Colorado, July 6, 1999.

gone

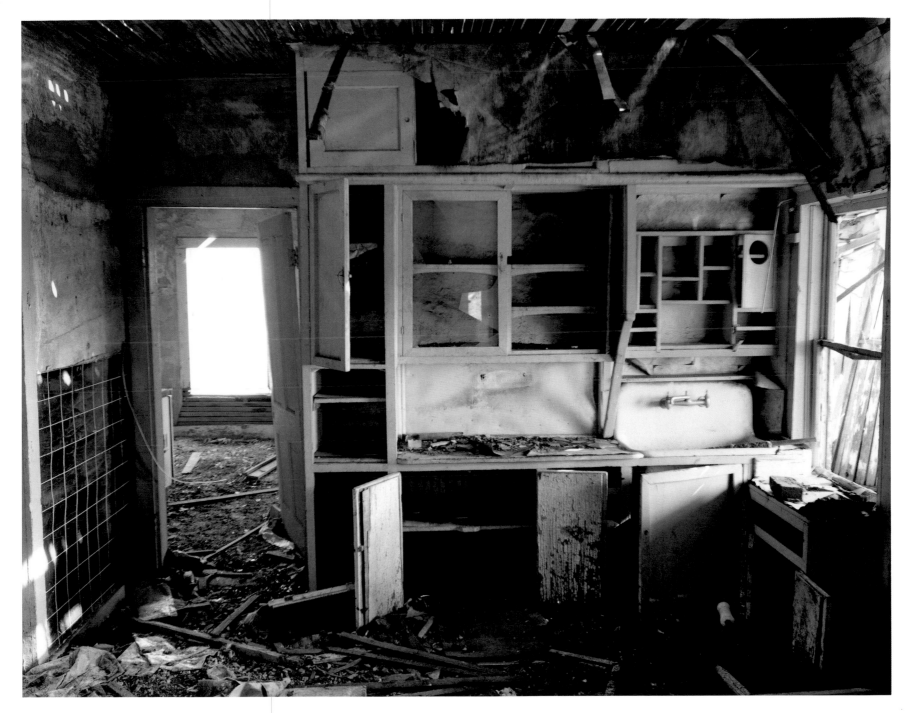

57. *Living room in a house near Ludlow, eastern*
 Colorado, July 6, 1999.

gone

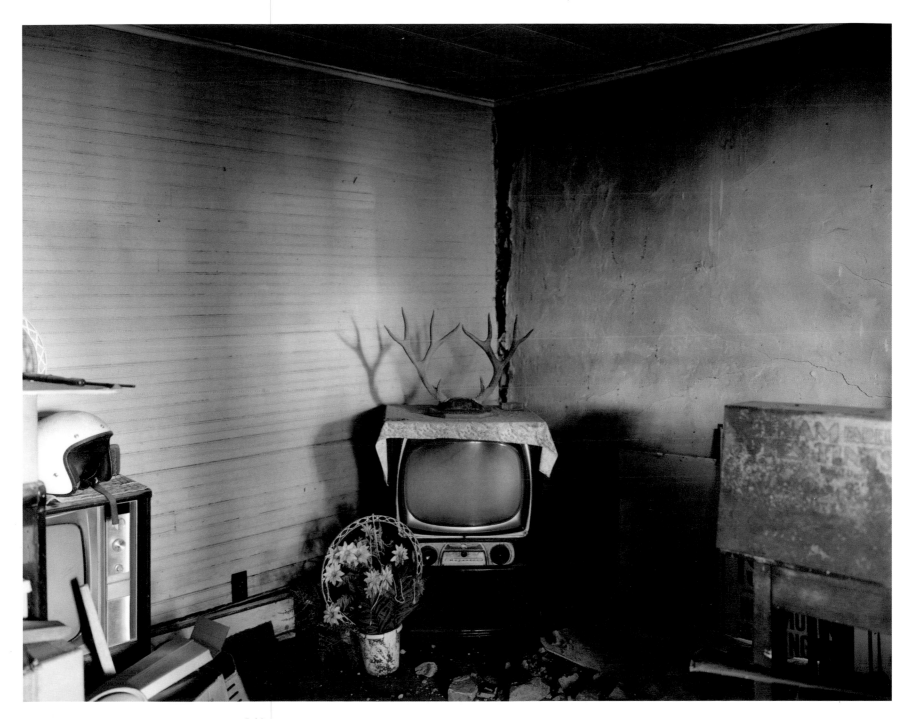

58. *View inside a house in Ancho, eastern New Mexico, May 14, 2000.*

gone

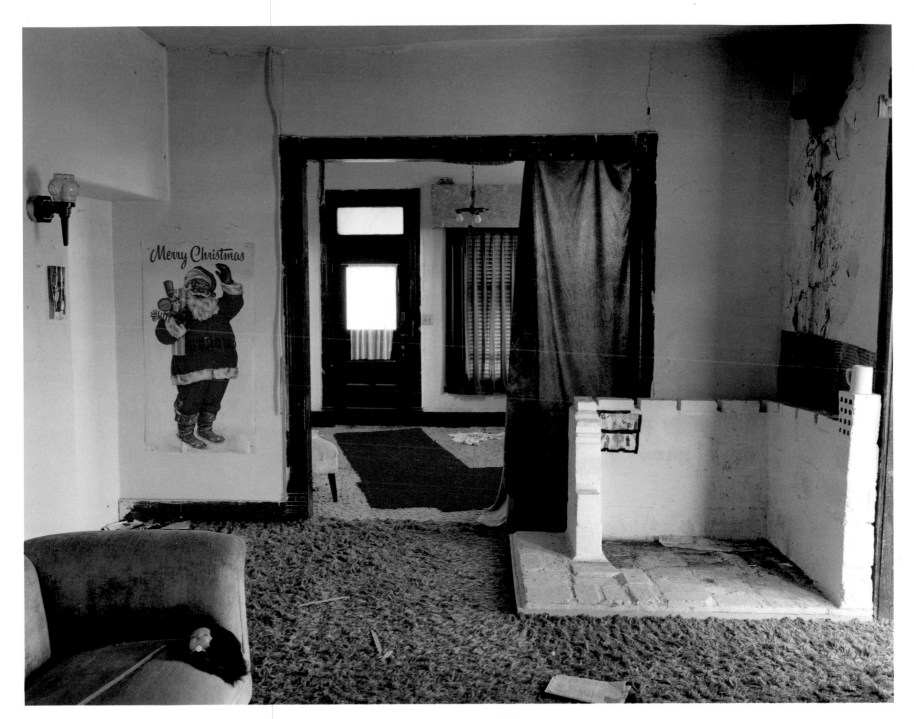

59. *Bedroom in a house in Ancho, eastern New Mexico, May 14, 2000.*

gone

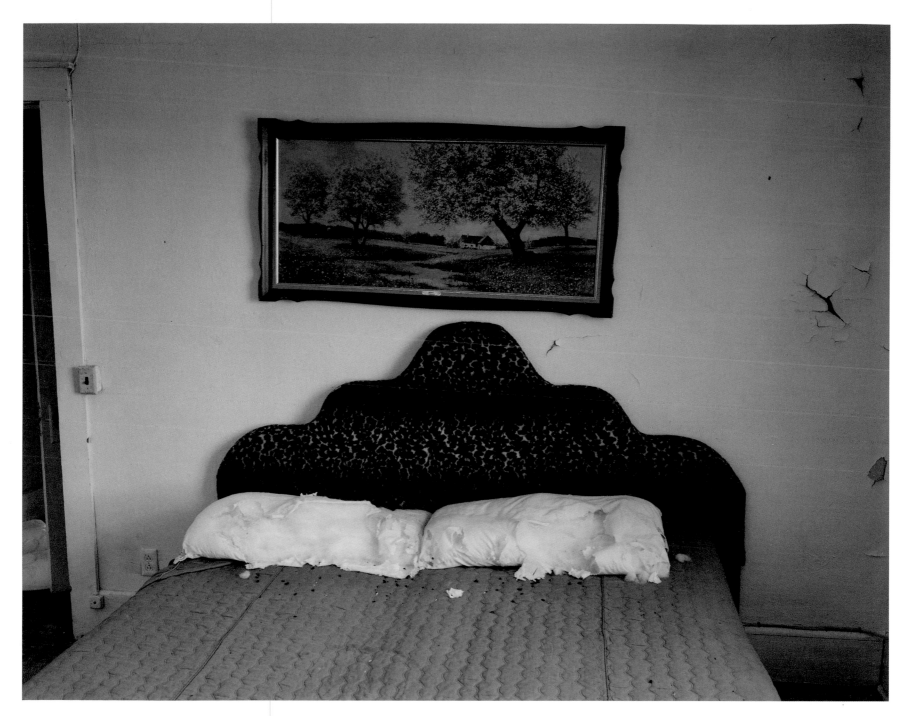

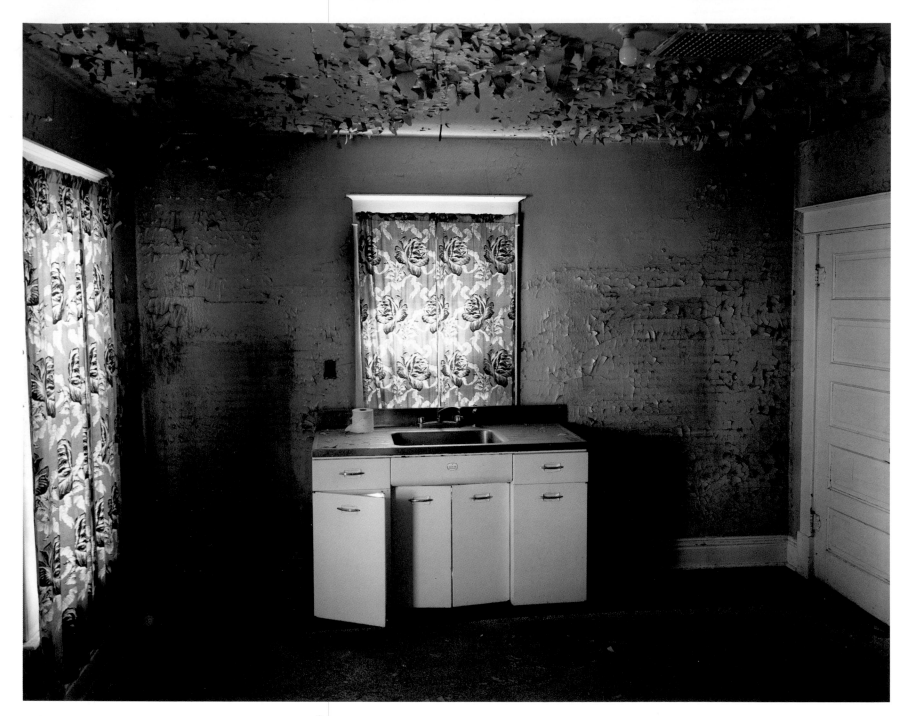

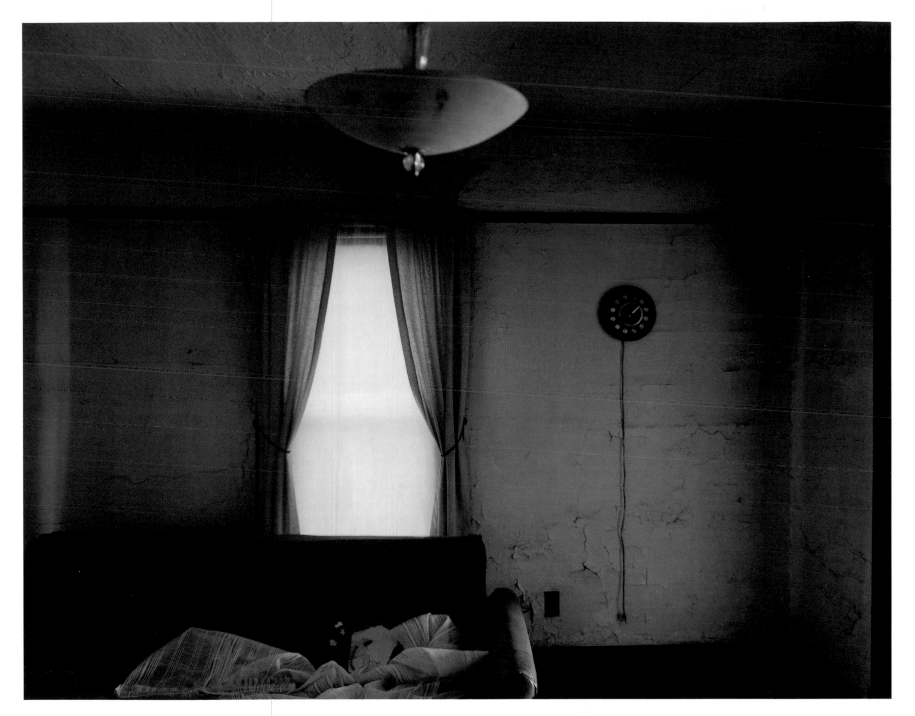

gone

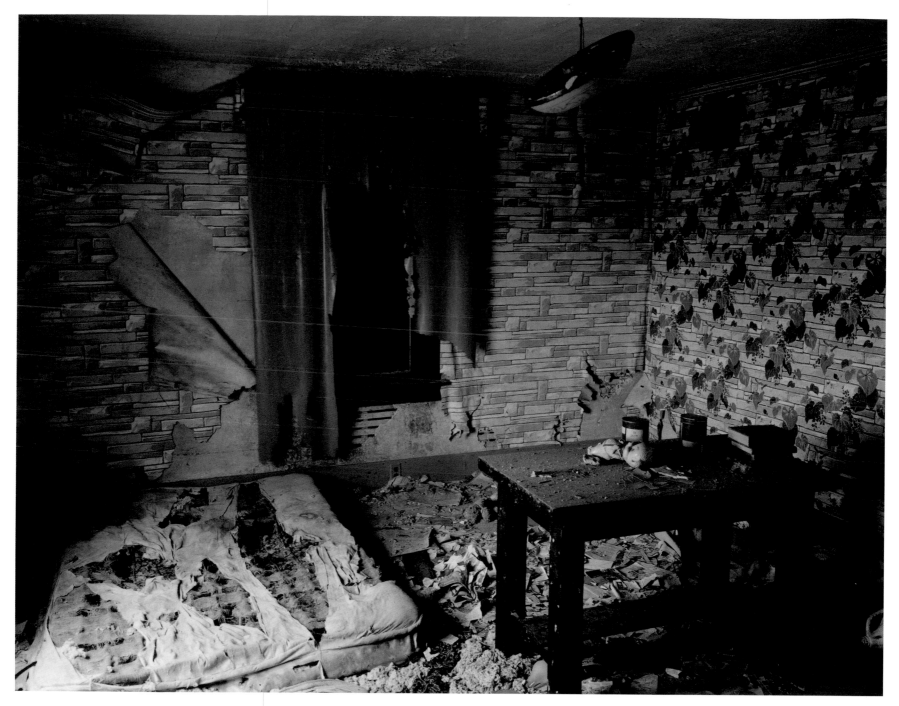

63. *Kitchen in a house in St. Phillips, eastern Montana, June 8, 2000.*

gone

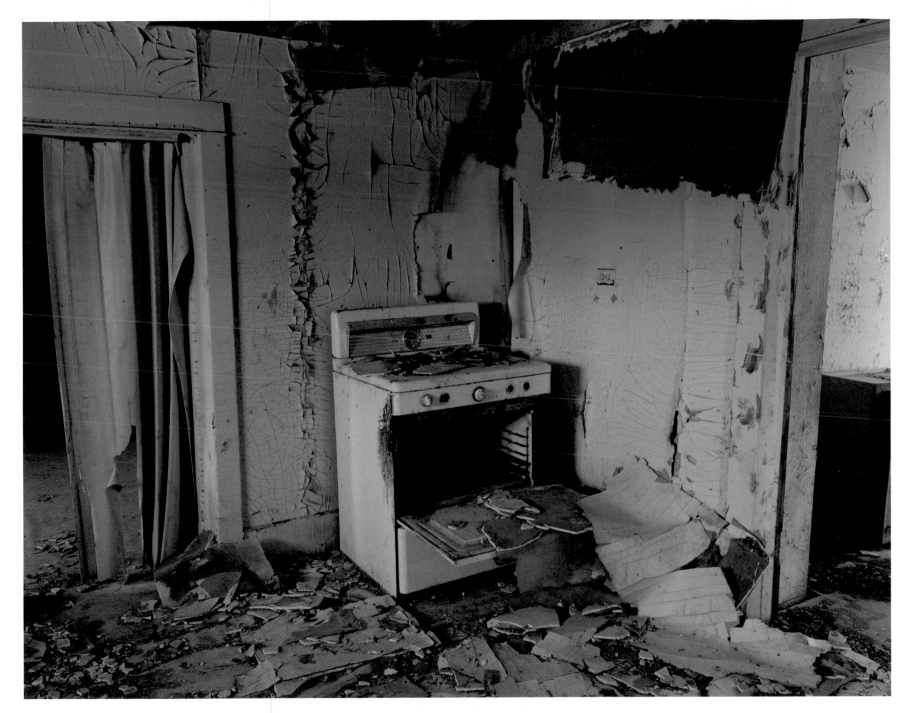

64. *Living room in a house near Scranton, western North Dakota, June 9, 2000.*

gone

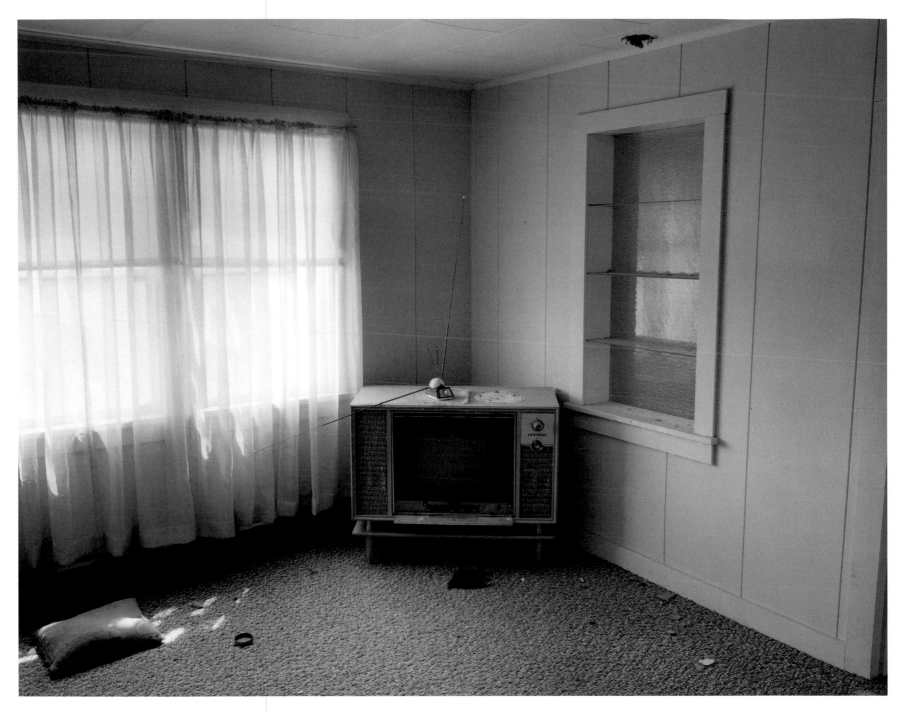

65. *Bedroom in a house near Scranton, western North Dakota, June 9, 2000.*

gone

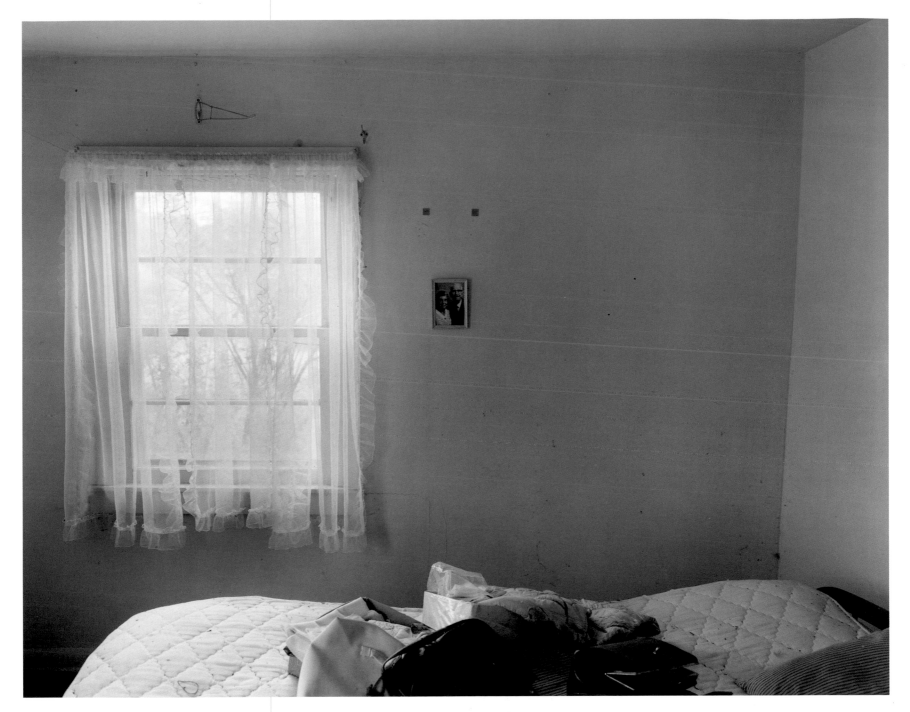

66. *Bedroom in a house south of House, eastern New Mexico, November 11, 2000.*

gone

67. Bedroom in a house in Pritchett, eastern Colorado, March 15, 2001.

gone

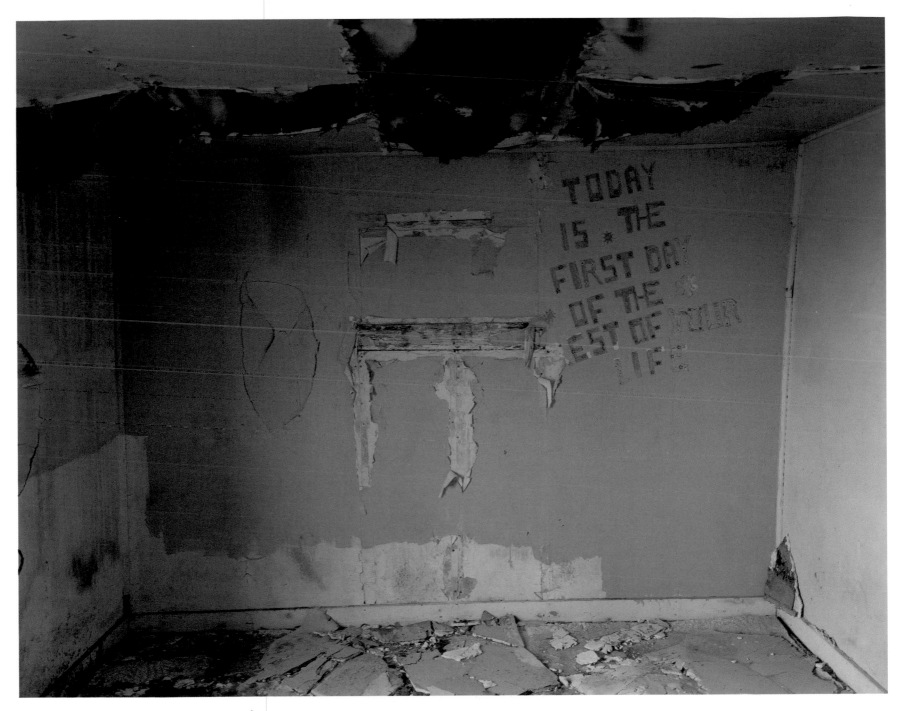

68. *Kitchen in a house in Burt, western North Dakota, May 16, 2001.*

gone

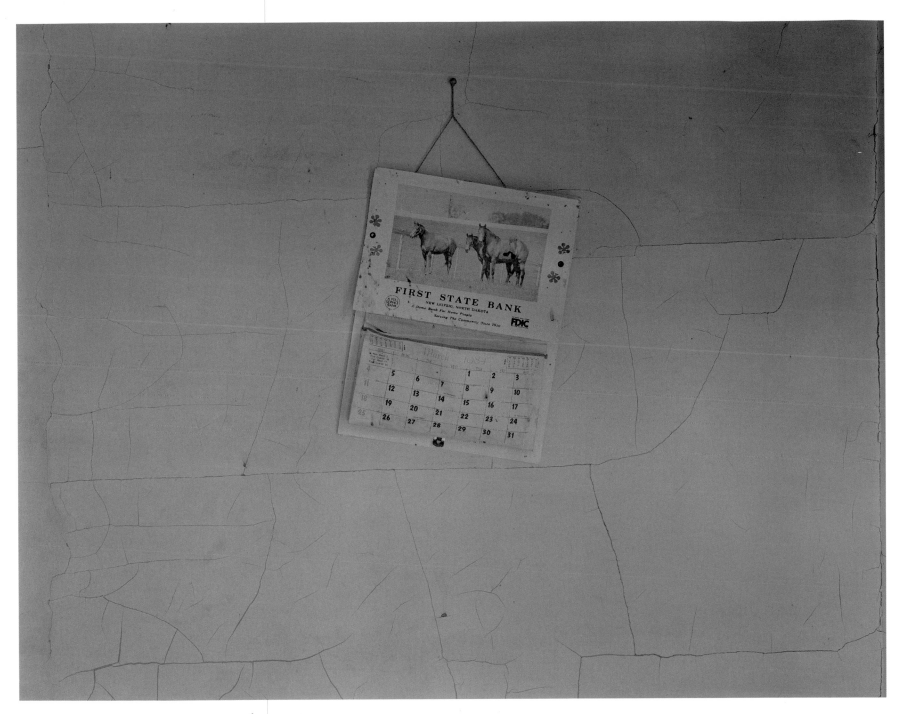

69. *Bedroom in a house in Grassy Butte, western North Dakota, May 17, 2001.*

gone

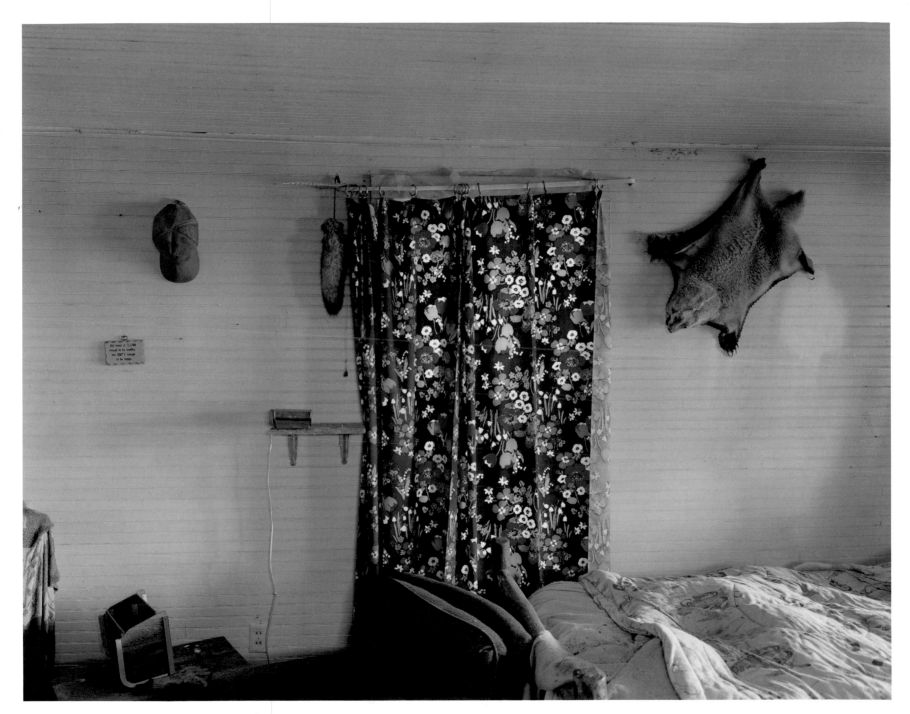

70. *Kitchen in a house near Regent, western North Dakota, May 18, 2001.*

gone

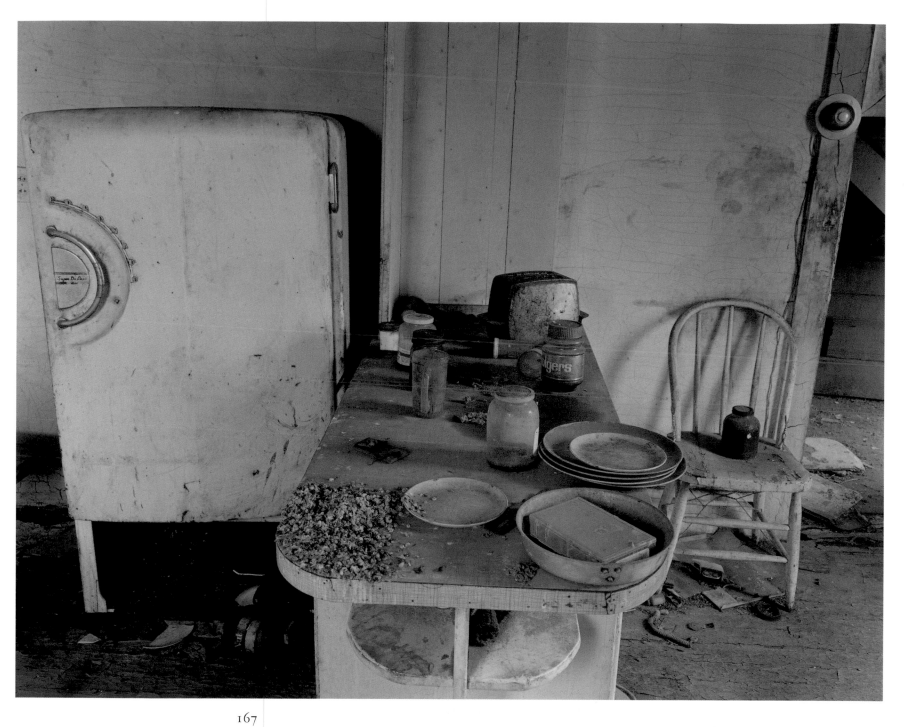

List of Plates

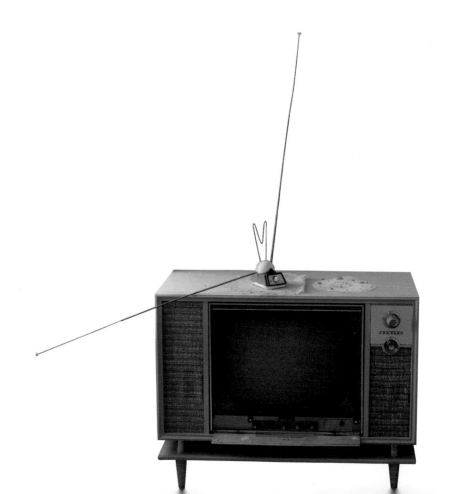

gone

gone

gone

gone

gone

gone

Acknowledgments

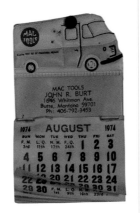

I would especially like to thank David Carpenter, Curtis Cravens, Rick Dingus, Lynn Grimes, and Willie Sutton for their early enthusiasm and interest in these photographs and this project. I also gratefully appreciate the advice and continual support of my mother who has always believed in my work as an artist, and the friendship of my neighbors in Baja Waldo, New Mexico.

For their contributions to the making and exhibiting of these photographs and to the creation of this book I would like to thank Lane Barden, Benton Brown, Bill Deverell, Beth Hadas, Paul Kopeikin, and Richard Levy.

The New Mexico Council for Photography awarded me the Eliot Porter Fellowship in 1999 for which I am grateful. That fellowship helped me make several important trips to the northern Great Plains which were crucial to my project.

I would also especially like to thank Dana Asbury for her interest in my project. Without her help and guidance this book would never have happened.

And finally, I would like to thank the authors who contributed such fine writing to the book: Merrill Gilfillan, Kathleen Howe, and Ev Schlatter.

For information regarding Steve Fitch's fine art photographs, please contact the Paul Kopeikin Gallery, 138 North La Brea Avenue, Los Angeles CA 90036.

(323) 937-0765
www.paulkopeikingallery.com

Credits

| Color Separations by Sung-In Printing Korea, Ltd. |

| Printed and bound by Sung-In Printing Korea, Ltd. |

| Text set in Garamond MT |

| Display text set in Fragile ICG |

| Book design and composition: Robyn Mundy |

| Editing: Evelyn A. Schlatter |